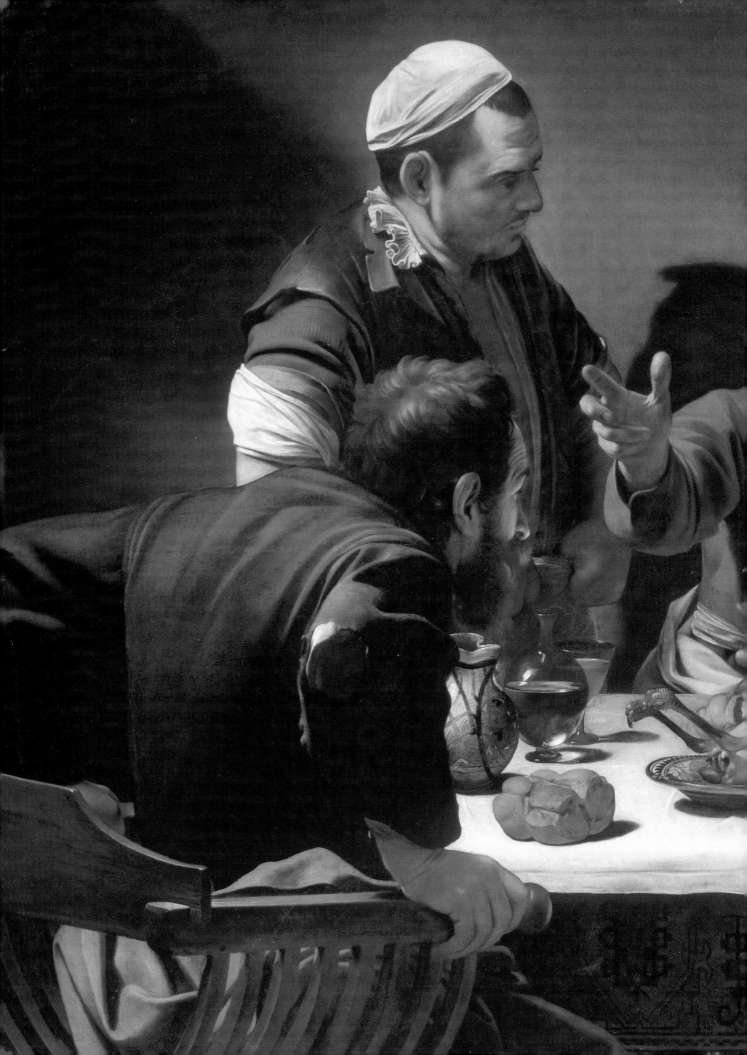

STEP·BY·STEP

Art School

PORTRAITS

First published in Great Britain in 1995
by Hamlyn an imprint of Reed Consumer Books Limited
Michelin House, 81 Fulham Road, London SW3 6RB
and Auckland, Melbourne, Singapore and Toronto

A CIP catalogue record for this book is available at the British Library

ISBN 0 600 58250 7

Produced, designed and typeset by Blackjacks
30 Windsor Road, London W5 5PD

Colour origination by Scanners
Printed and bound in China
Produced by Mandarin Offset

For Blackjacks:
Artwork and demonstrations for:
Silhouette, The Authors, Greek Granny,
Kavango Woman & Spanish Senorita – Roy Ellsworth
Self Portrait, Egyptian Man, Little Girl,
Clown & Mother and Baby – Ian Sidaway
Photography by John Freeman with assistance from Katy
Edited by Patricia Seligman

Credits

pp2-3, pp10-11, p12, p14, p15, p16 reproduced with permission by the trustees
of The National Gallery, London; p13 Louvre, Paris; p17 The Andy Warhol
Foundation for the Visual Arts Inc; pp18-19 Pierpoint Morgan Library, New
York; p34 © James Martin at Rachel Collingwood Management; p82 © Gina
Lollobridgida from the book *Italia Mia*; p108 © Alice Mertens 1974 from the
book *Kavango*; p132 © APA Publications/Hans Hoefer; pp142-3 reproduced
with the kind permission of Ian Sidaway.

Every effort has been made to contact all copyright holders of illustrations
used in this book. If there are any omissions, we apologize in advance.

Note: Although some of the projects in this book use book and magazine
photographs as their reference, you may only work in this way if the drawing
or painting is for practise only. You will be in breach of copyright if you try to
make commercial gain from your piece if you do not have the express authority
of the photograph's copyright holder.

The authors would especially like to thank Rod Green for all his help.

Contents

Chapter 1
Introduction

Portrait painting has been with us for thousands of years. The first sketches of figures, dating from the Ice Age, can be found on cave walls. Although not individual studies, they show us that humans have a natural desire to depict themselves. Portraiture in the purist sense, has only really existed for about two thousand years. And throughout that time – as with all painting styles – it has drifted in and out of fashion.

Portraiture's main source of patronage has traditionally been the well-to-do, who would commission representations of their families. Often in these paintings the subjects posed in their robes of office or their finest clothes and jewels to make a statement about their social standing. Remember that there was no such thing as a camera until the nineteenth century, which meant that portraits were the only means of recording a child's life, a family or even a newly-wed couple. Now, of course, the ready availability of photography means that the commissioned painted portrait has become something of a rarity.

However, this has not stopped the human face from being a constant as well as an easily accessible source of inspiration for artists throughout the ages. Approaches vary from super-realism to the abstract, so we have tried to present you with as many variations as we could within the confines of this book. After reading the brief history with its gallery to inspire you, study Chapter Two and then have some fun with the projects in the remaining chapters.

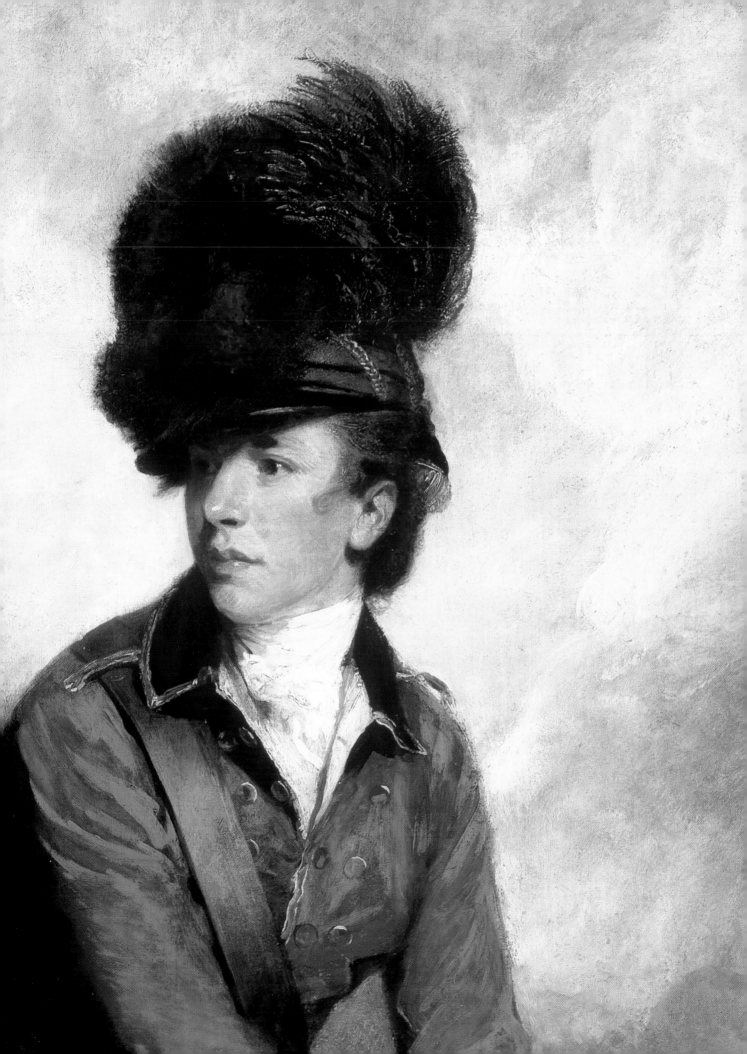

Introduction

A BRIEF HISTORY OF PORTRAIT PAINTING

Although the accepted form and composition of a portrait is a concept that has been developed, abandoned and re-invented many times since stone-age artists first decorated cave walls with images of their contemporaries participating in hunting scenes, the desire to capture not just the likeness but the character or essence of the subject has always been the artist's goal. The portrait artist, however, has rarely been the master of his own destiny. In the past, convention, religion and, of course, the whims of the patron paying the artist's fee all played a part in the final product.

In Ancient Greece, statues of gods and heroes were highly stylised, and this same approach was later used for portraits of leaders and intellectuals. These were portraits of real people transformed into super-humans who were perfectly proportioned and aesthetically pleasing. Artists have striven for this same technical mastery ever since. The Romans took this a stage further when Rome became the dominant cultural and economic force in the second century B.C. The vanity of wealthy and powerful Romans established the principle which would ensure the longevity of portraiture as an art form by employing Greek artists to produce flattering images which would enhance the social status of their subject. Even so, a Roman regard for realism ensured the face was a reasonably accurate rendition, but the body would often be idealised in the style of the Ancient Greeks, resulting in paintings, sculpture or reliefs with the head of a middle-aged dignitary and the body of an athlete or warrior.

The decline of the Roman Empire saw a decline in portraiture in the

1 *A Man in a Red Turban*, 1433, Jan van Eyck.

2 *Portrait of a Man*, 1475, Antonello da Messina.

Western world and it was not until the early stirrings of the Renaissance that it enjoyed a revival. The first portraits of this period were not painted as such but came about because artists were striving for an increased realism. Consequently, figures in religious paintings can be seen as 'portraits' of models. Flat profiles became three-quarter faces that revealed more of the character of the subject, giving it depth and life with the use of modelling and perspective. Giotto di Bandone (1266-1337) demonstrated a mastery of these new ideas in *The Annunciation To St Anne*. In the scene a young girl is at work, her face seen in a three-quarter attitude that is captured superbly in a natural and realistic portrait.

Wealth, power and status were again to play their part as Italian merchants and nobility, growing rich through trade and commerce, sought to emphasise their importance. The new breed of Italian scientists and artists understood more about how to measure and portray their surroundings. The equestrian portrait by Simone Martini (*c.*1284-1344) of Guidoriccio da Folignano can still be seen in the frescoes of the Palazzo Pubblico in Siena today. In the course

of the Italian Renaissance portraiture became the bread and butter of many artists.

Artists from other parts of Europe also contributed to the development of portraiture. The Fleming Jan van Eyck, who died in 1441, has been acknowledged as having developed an effective oil paint. His paint and varnish technique preserved the vitality of his colours, as demonstrated in two of his best-known works, *A Man in a Red Turban* and the wedding portrait of Giovanni Arnolfini and Giovanna Cenami. The latter was completed some seven years before the death of van Eyck and in it he created a fascinating impression of light and space around the young couple, who stand in a formal pose, holding hands, surrounded by clues to their past and future – for example, the marriage bed and a small dog to represent fidelity.

Another painter from Bruges, Petrus Christus (*d.*1473), produced the stunning *Portrait of a Girl*, thought to be Lady Talbot, who gazes out from the picture with a haunting stare. Christus's obvious interaction with his subject contrasts with the styles of other painters of the time. Rogier van der Weyden (1400-1464) preferred to

1

2

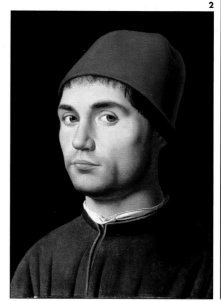

portray his subjects as though he had caught them unaware, as in his *Portrait of a Lady*.

Having spread the demand for portraiture throughout Europe, the Italian traders brought home the styles and techniques of foreign painters. Antonello da Messina's (1430-1479) *Portrait of a Man,* generally thought to be a self portrait, shows how he had studied the work of van Eyck. Antonello was a highly respected painter in his day and is credited with promoting the use of oil paint amongst his Italian contemporaries. Other Italians such as Giovanni Bellini in the north, who painted in Venice, incorporated aspects of the northern European portraiture style into their work. One massive Flemish composition which did make the journey south was *The Portinari Altarpiece*, which was commissioned by Tommaso Portinari, an Italian trader working in Bruges. This large-scale piece painted by Hugo van der Goes (active 1467-1482) featured life-size portraits in a religious scene of captivating detail and incorporating a landscape background.

The combination of a religious scene with elements of portraiture was also used by one of France's foremost artists of the fifteenth century, Jean Fouquet (1420-1481). His *Diptych Of Melun* shows Etienne Chevalier, Chancellor of France, kneeling next to St Stephen. This part of the diptych clearly demonstrates how Fouquet understood the three-dimensional form.

Techniques and ideas were now being shared throughout Europe, and the fame of the artists who practised them was becoming a phenomenon in its own right. Although he produced relatively few paintings, Leonardo da Vinci (1452-1519) created the most famous portrait of all time, the *Mona Lisa*, also known as *La Gioconda*. Despite its notoriety, surprisingly little is known about the painting. The

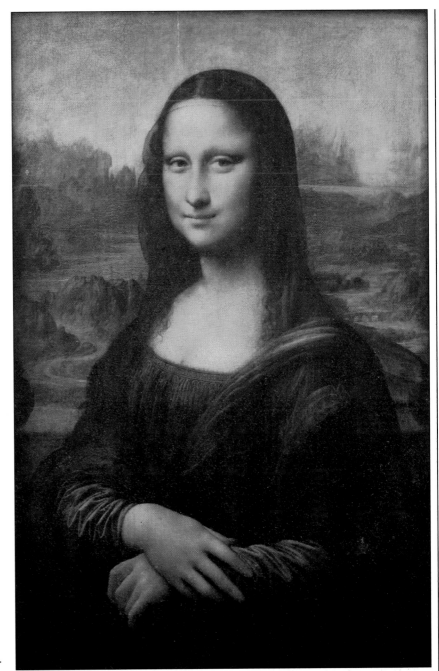

identity of the subject has always been something of a mystery, with few of the usual clues, such as jewellery, distinctive clothing or background scenery, that Leonardo incorporated in other works. *Lady with an Ermine*, for example, included an ermine, part of the emblem of Il Moro, whose mistress, Cecilla Gallerani, was the subject of the

Mona Lisa (La Gioconda), c.1503, Leonardo da Vinci.

portrait. The *Mona Lisa* may well be based on a number of different models, having been painted over a period of years while Leonardo was studying anatomy at a hospital in Florence form 1503 to 1506. The layers of transparent paint used to

A BRIEF HISTORY OF PORTRAIT PAINTING

build up the picture were applied with an increasing understanding of skin tissue and bone structure. Leonardo took the painting with him wherever he went and it was seen at various stages of completion by many other artists, including Raphael (1483-1520), who produced another landmark in portraiture, *Baldassare Castiglione*, a painting of a well-known gentleman and courtier. The calm eloquence of the work became the inspiration for centuries of portrait painters.

Knowledge and technique acquired during the Renaissance led to ever more sophisticated and realistic paintings and nowhere was the demand for new art greater than in Venice. The commercial success of its inhabitants led to the building of grand houses which the owners hung with fashionable new paintings. Painting grew into family businesses operated from 'factories' such as that of the Bellinis. Giovanni Bellini (*c*.1430-1516) was an immensely talented artist following in the footsteps of his father, the painter Jacopo (1400-1470). His brother Gentile (1429-1507) and brother-in-law Andrea Mantegna (1421-1506) were also painters.

Between them they produced scores of religious scenes and portraits but it is Bellini's use of the new oil paint that makes him special. His applications of transparent glazes of paint to build rich and subtle colour blazed a trail for later artists such as Titian (1487-1576) and Giorgione (1475-1510).

With an increased knowledge of anatomy and their confidence in the new techniques, the Renaissance artists produced realistic portraits, but would still have been required to 'flatter' the subject if they wanted to continue to receive commissions. In painting themselves, however, they could experiment more freely to try to capture expressions, moods and character which might not have been to the liking of an employer. Rembrandt van Rijn (1606-1669) painted himself many times and similarities to his own features can be found in many of his portraits of others. In studying facial characteristics it is obvious that any artist will be able to devote more time to observing his own features than anyone else's and most of the great painters experimented with self portraits. Although Velasquez

(1599-1660) was really the official court painter, as you can see from the portrait of King Philip IV on this page, he also experimented with self portrait. A prime example of this is *Las Meninas*. The subject of this painting of the Spanish court is really portrait painting itself. The King and Queen of Spain are only seen reflected in a mirror and the focus of attention is the artist himself. The painting is viewed, therefore, from the perspective of the artist's model, although use of mirrors and the confusing results suggest that Velasquez was trying to emphasise that, despite the great strides that had been taken in making portraits realistic, painting was, in fact, still just an illusion.

Velasquez and his friend Rubens (1577-1640) – who painted the famous portrait of Susanna Lunden – were greatly influenced by the work of Caravaggio, whose turbulent lifestyle led to his early death in 1610 at the age of just 37. Caravaggio's paintings were often rejected by his religious sponsors as being too disrespectful, as he would include the physical imperfections of the models he used to stage his religious scenes, sometimes

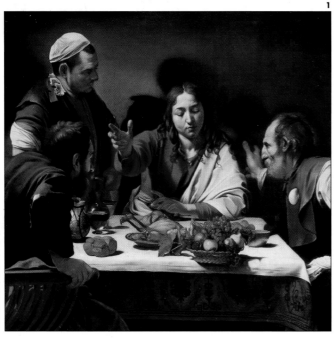

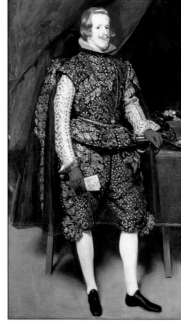

1 *The Supper at Emmaus (detail)*, *c*.1598, Caravaggio.

2 *Philip IV of Spain in Brown and Silver*, *c*.1630s, Velasquez.

3 *Portrait of Susanna Lunden (Le Chapeau de Paille)*, 1622-5, Sir Peter Paul Rubens.

4 *Self Portrait Age 34*, 1640, Rembrant.

5 *General Sir Banastre Tarleton*, 1782, Joshua Reynolds.

3

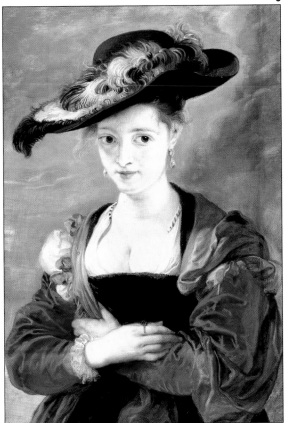

4

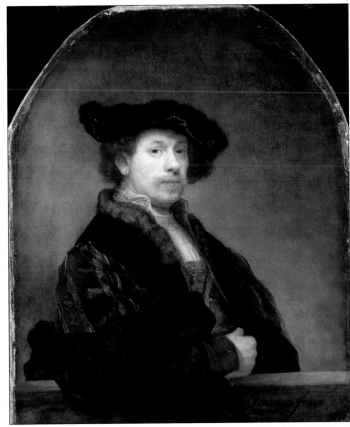

5

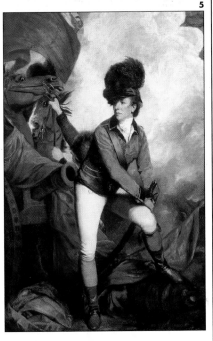

depicting the saints in a less than flattering way as ordinary people. *The Supper at Emmaus* certainly displays this tendency, but it is for his use of strong light to create fullness and form that Caravaggio's paintings are most noteworthy.

The extravagance and proliferation of ornamentation which crept into the art of the sixteenth and seventeenth centuries set it apart from its Renaissance influences and this period has come to be known as Baroque. European portraits had tended to be of royalty, the aristocracy or of a religious nature until the Dutch began to emerge as an independent nation and a major commercial force. The different social hierarchy in the Netherlands, where wealth was acquired or earned rather than inherited, led to a different kind of portraiture featuring ordinary people in the way pioneered by Caravaggio. Frans Hals (1581-1666) was a major portrait artist of the time

and his *Regents of the Old Mens' Home* is a perfect example of the new style of people's portrait.

The most famous of the Dutch masters must surely be Rembrandt van Rijn (1606-69), who had a reputation for originality in his portrait compositions. He introduced movement into portraiture, catching his figures in the act of sitting down or standing up, such as in *The Board Of The Clothmakers' Guild*, where five executives examine the accounts, one of whom is about to stand. Tricks like this helped to maintain Rembrandt's interest in his work, whilst also pleasing his employers, but the death of his wife only a year after the birth of their only son seemed to rob Rembrandt of his vitality and Van Dyck (1599-1614) took over as the most popular artist of the day.

It was not until the eighteenth century that the English school of portrait painters began to emerge and

grow in stature. Sir Joshua Reynolds (1723-1792), the first president of the Royal Academy, sought his inspiration not from the innovations of the Dutch

A BRIEF HISTORY OF PORTRAIT PAINTING

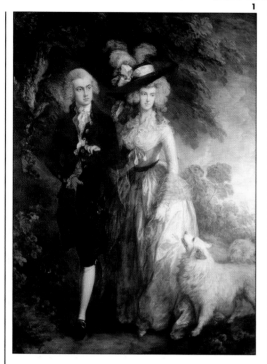

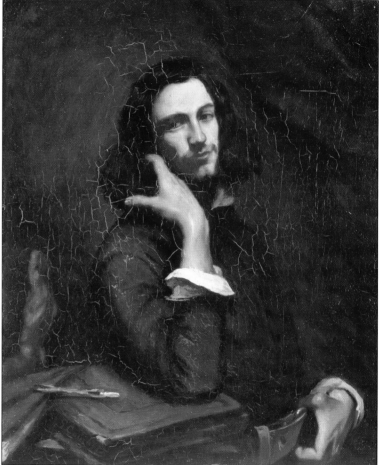

1 *The Morning Walk*,
1785, Thomas Gainsborough.

2 *Self Portrait, c.*1840s, Gustave Courbet.

but from the perfect ideals of the Renaissance, as seen in his portrait of Sir Banastre Tarleton. He was determined to bring on young artists in the classical style, although he was capable of producing less formal and more gentle pieces such as *Nelly O'Brien*.

In complete contrast, the characterful, almost casual, portraits of William Hogarth (1797-1764), epitomized in such works as *The Shrimp Girl*, demonstrate a different line of thinking altogether. He was unwilling to become bogged down in the pompous rigidity and seriousness of classical art. Thomas Gainsborough (1727-1788) painted with yet another, elegant and distinctive style, preoccupied more with the high society of eighteenth-century England which is apparent in *The Morning Walk*. English painting during this period was, therefore, developing along several fronts and remains the

main area of interest until the French Revolution brought forward some remarkable works of art.

Jacques-Louis David (1748-1825) sprang from the turmoil of the political and artistic revolution as a major international influence. His *Coronation of Napoleon* included over 100 portraits, but the severe classical style of his work, and of those who followed his lead, also triggered a backlash. The Romantic movement grew from escapist literature full of imagination and atmosphere from England and Germany. Eugène Delacroix (1798-1863) was the foremost exponent of the Romantic style. His free flowing expressive and emotional paintings are totally opposed to the highly structured and restricted classical works. Much of the substance of Delacroix's work came

from his extensive travels – notably his Moroccan trip in 1832, but he also painted some memorable portraits of his friends, such as *Chopin* in 1838.

Another highly renowned artist during this period was Gustave Courbet (1819-1877). Looking back to the Dutch masters and Caravaggio, Courbet led the field with a new style of realism, taking everyday events and promoting them as being worthy subjects for fine art. His first major work, *The Burial at Ornans*, is a life-size rendition of the mourners at a funeral – portraits of his father, family and friends. By introducing real people and events in such a way, Courbet developed the role of the artist as an observer and changed the purpose of portraiture from the celebration of wealth and status to a more candid image of an individual,

painted as much for the artist's benefit and enjoyment as for that of the subject.

The invention of photography also contributed to the changing nature of portraiture in the nineteenth century as photographers initially attempted to supersede the role of the painter. Artists like Courbet and Delacroix began to experiment with photography as an aid to their work, as did Edgar Degas (1834-1917). Degas drew his influences from wherever he perceived there to be lessons worth learning, reaching into the past, studying contemporaries like Courbet, becoming associated with the mid nineteenth-century Impressionists and appreciating the beauty of art imported from the Far East. His portraits give the impression of casual scenes observed from real life as in *The Absinthe Drinker* (1876), but he often employed professional models or used friends to pose for his paintings.

The continued technological and artistic development of photography has not, as it was once expected, brought about the complete demise of portraiture. Most of the major artists of the last hundred years have continued to paint portraits, sustaining it as an art form, although the natural or realistic image lost its importance with the emergence of the Impressionists. This group radically changed the accepted use of light and colour, painting shadows in contrasting hues and breaking up colours to give a feeling of the subject rather than creating a realistic image. Vincent Van Gogh (1853-1890), Henri Matisse (1869-1854) and Pablo Picasso (1881-1973) all applied their own theories and styles to the portrait.

The attitude to portrait painting has also changed with the social trends of the twentieth century. In a strange reversal of positions, it has become a status symbol to have a famous or important artist seek to paint your portrait, whereas before it

was the fame or importance of the subject that was paramount.

David Hockney (*b*.1937) presents an uninhibited portrait of *Celia in Black Slip and Platform Shoes '73* in a style using line and colour which demonstrates the artist's sense of humour and powers of observation, projecting his own character into the painting whilst capturing the essence of the subject. Andy Warhol's (1930-1987) multiple silk screen images of Marilyn Monroe use vibrant colours on a simplified portrait to convey the vitality of the film star, making the image recognisable to anyone familiar with Marilyn Monroe. The features of the actress remain constant, but the colours used in her hair and on her mouth are an exaggeration of the dyed hair and cosmetics used by Monroe, bringing out the sense of humour and fun associated with her and allowing the artist to create a

portrait image in a satirical, yet affectionate manner.

To have desecrated the image of a public figure in such a way during the infancy of portrait painting might well have led to the artist's execution, but the evolution of portraiture has at last reached the stage where the artist is more in control of their own creation and has the freedom to reach for the ultimate goal of capturing the spirit of the subject as opposed to just the likeness. While a limited number of formal portraits of the rich and influential patrons will, no doubt, continue to be painted in a realistic manner, portraiture can surely only progress as an art form with artists at liberty to express themselves and interpret their subject using styles and techniques that are limited only by their own imagination and invention.

Marilyn, 1962, Andy Warhol.

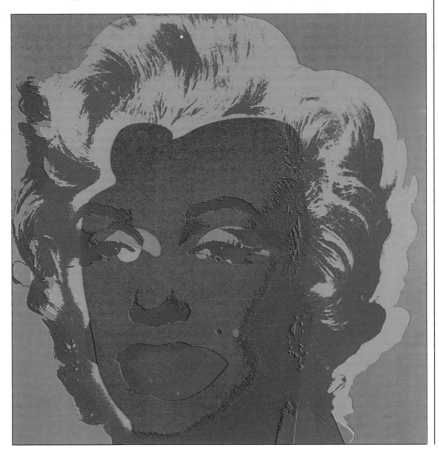

Chapter 2
Where to Start

In this chapter we explore the fundamentals that go into drawing or painting a good portrait. Study the following pages before progressing on to any of the projects.

With portraiture, it is rarely difficult to find a model. Even if your talents have yet to be recognized, people are always curious and flattered to be asked to 'sit' for you. If you don't have any luck in finding someone to pose, you can paint or sketch someone at work or play – ironing or watching television. Of course, if you really have no alternative model, you can always paint yourself by looking in a mirror.

Once you have got your model lined up, it is worth spending a little time on preparation; setting up the model, the lighting and your painting materials. Time spent on sketching is particularly worthwhile as it will help you fully explore the face you are trying to capture on paper.

This chapter also explores the structure and proportions of a face, which will help you paint your chosen model from any angle. We look, too, at the various features – the eyes, nose, lips, ears – and show you how to overcome the common problems in painting them. Finally, we give you some tips on how to capture a likeness, not only by getting the facial features in proportion, but also by developing the shape and texture of the sitter's body and clothes.

Where to Start

WHAT TYPE OF PORTRAIT

You first have to decide what type of portrait you want to paint or draw. Do you want to concentrate on the face alone or is it to be a full-length portrait? Do you want to portray the person in their favourite place – in a garden maybe, or curled up reading a book? Do you want a coloured background or will you show your sitter surrounded by a few prize possessions, giving a clue to their character? Will it be a formal studio portrait or an action portrait in the fresh air, sailing or biking? Your choice will be influenced by what you like to paint and how complicated you want your portrait to be.

Whatever you decide, remember that the closer you are to a person, the more important it is to get the individual features of the face right. If, for example, you paint a person in their sitting room, it will contain many clues to that person's character from its decor, the possessions and nick-nacks scattered around it. All these things help to build up their portrait by association.

Your Model

There are many ways of arranging a model for a portrait. The pose can be informal – sitting on a sofa or lying on the grass outside. Alternatively,

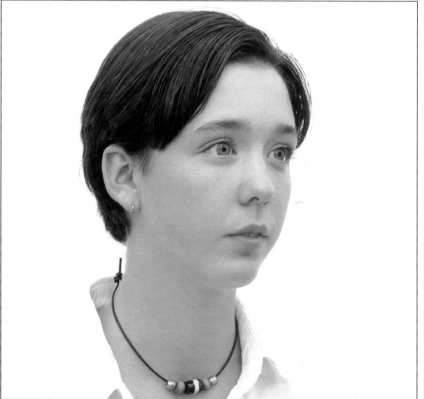

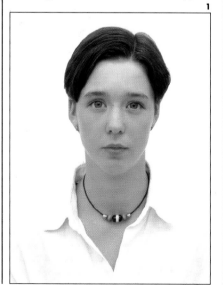

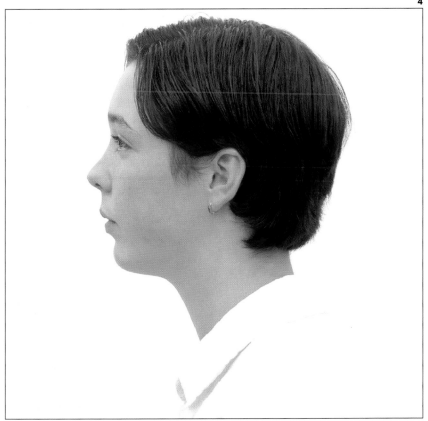

The photographs on this spread illustrate the substantially different shapes the human head takes on when the viewpoint is changed. Straight-on (*1*) you see an oval outline, but a step to either side (*2&3*) flattens the oval towards a circle. In addition, the bone structure of the forehead and cheeks becomes apparent. A step further and you are into full profile (*4&5*) where the structure of the face is at its most pronounced. By viewing your subject from below (*6*) and above (*7*) the effect is different yet again.

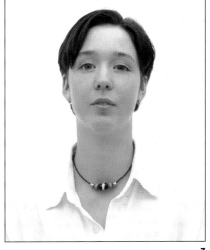

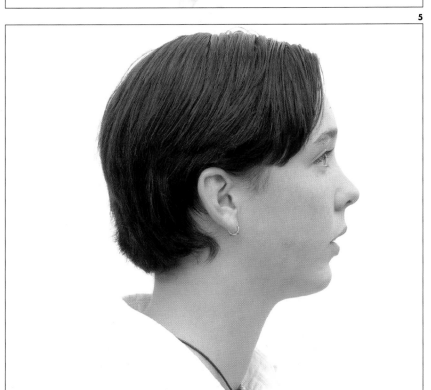

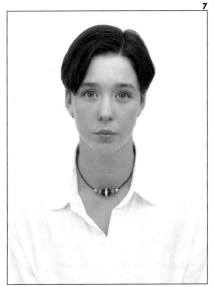

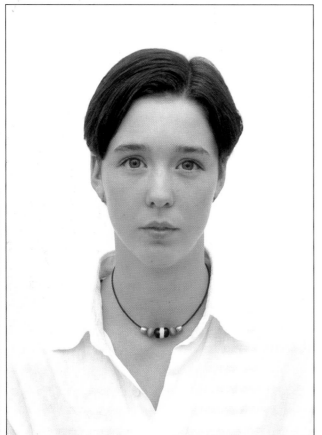

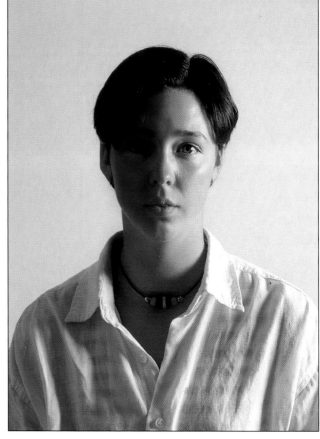

the sitter can be posed to make an interesting composition, maybe with the face in profile or the torso twisted. Whatever pose you decide upon, you have to be aware of the comfort of your model if you want him or her to maintain the position for any length of time. This can also be applied to the expression on the face. It is difficult, for example, to hold a smile for any length of time.

It is a good idea, once you have arrived at the perfect pose for your model, to take a polaroid photograph so that the model can easily return to the pose and, if necessary, you can complete the portrait even if your sitter gives up on you!

Lighting

Lighting is very important, as you will discover. You need to take into account the type of light you want: natural or unnatural, its direction, its

strength, and also its colour and depth. The lighting you choose will depend on the type of portrait you are painting or the character you are trying to portray. Experiment with lighting on your own face by using a hand mirror. Notice the shadows cast by your features. Stand close to the window and then move back from it, into a dark corner of the room. Try with a strong overhead unnatural light and then with a spotlight trained on the face from one side.

Natural light from a window is considered kinder to a face than an artificial light source. Daylight is more mellow, resulting in no ugly shadows being cast over it. The density of natural light is usually more flattering than harsh artificial lighting.

If your model sits facing the main source of light, his or her face will appear flatter and less sculpted because there are no shadows in the

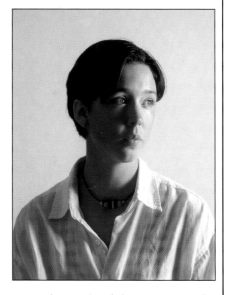

eye sockets, around the nose or mouth. It is best to paint in a gentle general light with more directed light coming from one side. You can make your portrait more dramatic by directing stronger light more obliquely from the

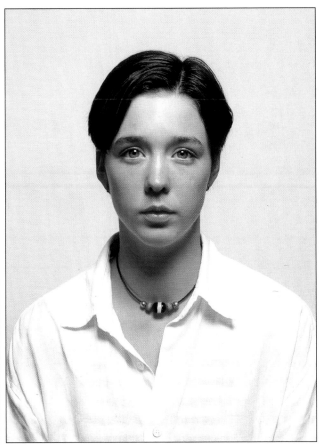 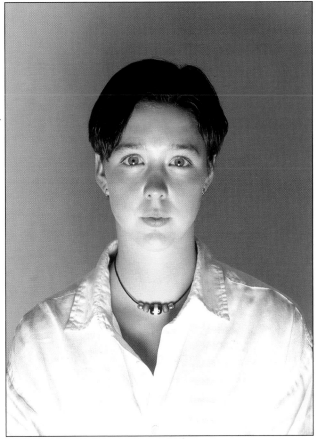

The photographs on this spread show how, through the use of directed interior lighting, a vast range of different effects can be achieved. Lighting can be used in a wealth of ways – not only to create atmosphere. With a bit of care and attention you can use harsh lighting to pick out the bone structure in the face to make the sitter look older or thinner or to create a melodramatic effect. Softer lighting tends to have the opposite effect, potentially taking years off your model.

side so that one side of the face and body is in deep shadow. These effects are the same whether you use natural or artificial light.

Bright, harsh light flattens the subtle curves of the face, reducing it to extremes of contrast. Bright light from above produces cavernous dark eye sockets and dark shadows cast by the nose and lips – appropriate for portraits of historical villains maybe, but not very flattering to your greatest friend!

Experiment with colour too. If nature does not oblige with warm sunlight or cool moonlight, place coloured filters over a lamp. A figure basking in golden sunlight will give a very different impression to one seen in the rosy glow of a fire.

Getting Ready to Paint

Having organised your model, you need to consider the practicalities of painting them. You need to be seated or standing so that you can see your model by looking across or beyond your support just by moving your eyes. It is hopeless to arrange your painting gear and then your model in

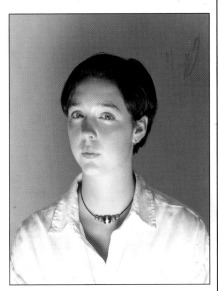

such a way that you have to come out from behind an easel, stand up, or swivel around in order to see them. Whatever medium you are using – and these are individually explored in the coming chapters – make sure that

you have everything you need close to hand before you start. It is distracting for you and your model if you have to keep wandering off to find things.

Proportions of the Face

The proportions of the face stay the same whether the sitter is facing you head on, half turning, or in profile. Seen head on, there are a few general points worth noticing: the eyes come about halfway down the head, the ends of the eyebrows align with the tops of the ears, and a line through the base of the nose runs through the base of the ears. A vertical line can be taken through the inside corner of the eye to the outside width at the base of the nose. Of course, faces vary enormously, and these proportions are only a rough guide. However, by knowing about them, you can see how the face of your sitter varies from them and this will help you to capture their likeness. The features in a baby's face, for instance, appear crowded in the centre of the face. By adulthood, the features have spread out.

Applying Perspective

If you are looking at the face from above or below, then the proportions change. Sketch a willing model with face upturned and notice how the area between chin and nose now dominates. Notice the rounded planes – over the top of the cheekbones, the brow and the hairline. Now sketch the face from above. The brow and nose now dominate over a reduced chin.

Getting a Likeness

This is always the aspect of portraiture which unnerves the artist. Yet it is a case of careful, objective observation. Look at the shape of the face – is it round or square – and then the proportions. You can fix these proportions by measuring with your thumb along a pencil in your out-stretched hand. A good exercise is to take a photograph of a friend, turn it

Facial Muscle Groups

orbicularis oculi

frontalis

orbicularis oris

buccinator

masseter

upside down and then sketch it. This will force you to look at it objectively as a series of lines and interlocking areas of light and shade. The results are often surprisingly good.

Sketching the Face

You will learn a lot by sketching faces. Sketch any faces you can find – photographs in magazines, from photo albums, or willing family and friends. By doing this you will build up a gallery of heads of different shapes and sizes, heads with and without hair, faces with glasses, beards and moustaches, tired faces, old and

Above and Opposite Page: Beneath the skin lie the bone and muscle structures. It is these which work together to give the face it contours and so establish the general features.

young faces. You will notice how smiling faces push up the cheekpads against the eyes, half closing them. You will observe the texture of skin – from shiny, tight, baby skin to sagging, wrinkled octogenarian skin. All this and much more you can glean from watching and sketching people around you.

Modelling the Face

Learning to model the face takes practise. We tend to forget that the face is a series of rounded planes. The brow is rounded, the cheeks, the eyeballs in their sockets, the bridge of the nose, the mouth – all are curved. If you can remember to sketch and paint these as curves and rounded planes with appropriate shadows, then you are halfway to achieving a realistic image.

You will find shadows and shade where the light is obstructed. If the light comes from above, a fringe will cast a shadow, as will the brow, the nose, the pads of the cheeks and the lips. Areas of highlight will appear on the brow, the bridge of the nose, the tops of the cheeks and the chin.

With a soft pencil, and by using a photograph of a face, draw the shape of the head and then map out the areas of tone without 'drawing' the features with lines. Shade in the areas of dark tone and mid-tone, leaving the highlights white. You have to be strict with yourself. When you have finished, you will find the facial features have emerged through these patterns of tone.

Body Shapes and Clothes

A portrait is rarely just a face. The body of the sitter, even if only part of it is viewed, is equally important in building up a character, as are the clothes. If you have trouble with getting the proportions of the body right, try seating a figure in a chair. Draw the chair first and use it like a grid to place the main lines of the body in it.

Some artists, such as the seventeenth-century Spanish artist Velázquez, delighted in painting the details of their sitter's clothing.

Velázquez had a talent for painting fine lace and brocades as well as the fine black woollen cloth fashionable at the time.

Clothes help to define the character and give shape to the body. The curved edge of a cuff will describe the plumpness or angularity of a wrist. However, you do not need to paint the body or clothes to the same degree of finish as the face. Some artists just fade out the detailing at about the waist, allowing pencil sketch lines and the paper or canvas to show through. Alternatively, you can block in the clothing in much bolder and broader strokes.

Hands

It is often said that hands are as expressive of the character of a person as is the face. Hands can offer another point of interest in a composition, balancing the face. Look at people's hands and notice how they hold them. Take a week when you only sketch hands – on the bus, at work, from photo albums and magazines.

Skin Tints

There is no magic recipe for mixing skin colour because there are so many different tints of skin from 'white' to 'black'. In each project in this book we give you the colours used to mix the skin tones and you will see how they vary between artists. Try some of these yourself and build up a ready reference of skin tones.

For opaque paints, like oils, acrylics and gouache, you can block in the facial area with a mid-tone flesh tint and then work down to the deepest shadows and up to the highlights from the mid-tone. For pastels, tinted papers can be used in the same way. For watercolour portraits, try mapping out the areas of highlights and shadow, reserving the highlights as white paper and building up the shadows with superimposed washes, wet on dry.

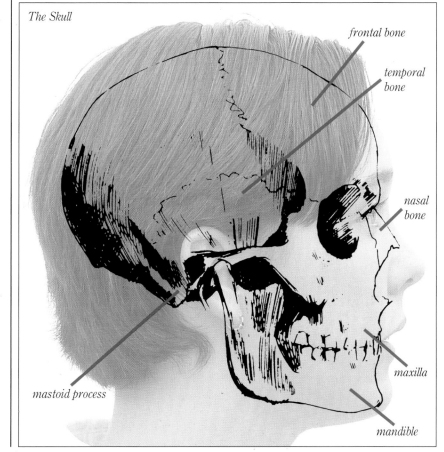

The Skull

frontal bone

temporal bone

nasal bone

maxilla

mastoid process

mandible

Chapter 3
Without Colour

Tonal drawing in monochrome is a fundamental skill that will greatly benefit any budding artist. Without the insight that producing a picture in 'black and white' gives you – especially with regard to how tone can be built up – it is much harder to be successful when working in colour.

Every artist's most precious possession should be their sketch book – the equivalent of a visual diary – where you can rough out ideas and refer back for inspiration. Obviously a 'sketch' requires a quick medium, and you cannot get much quicker than a dry monochrome medium.

There are many different media which can be used for drawing, and all are challenging yet fun in their own way. In this chapter we focus on just two, graphite and charcoal, but once you feel confident with these, you will no doubt want to experiment with many others.

Graphite pencils are what everyone always associates with drawing. Although the simplest of drawing tools, they are remarkably versatile. We have cheated slightly and made use of graphite sticks since they produce such bold marks, but the graphite projects will work perfectly well with an ordinary 'lead' pencil.

Charcoal sticks are perfect for the beginner as they are bold and very responsive to use. There is no messing around, as you simply pick up a stick and start to sketch.

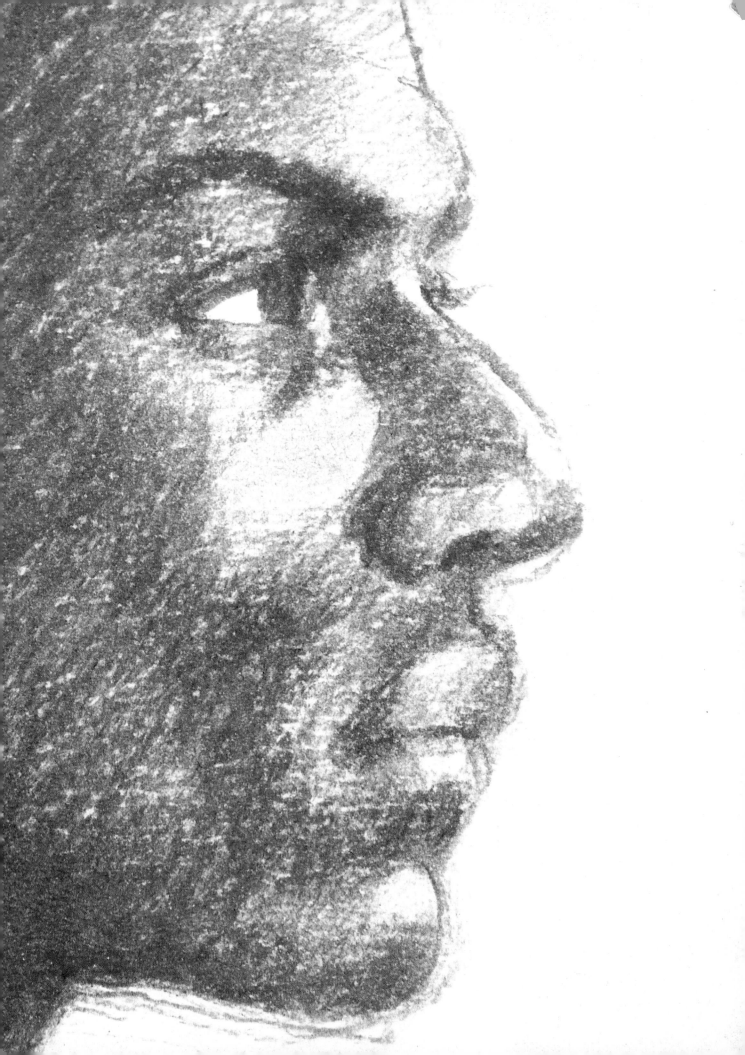

Materials

GRAPHITE AND CHARCOAL

Graphite

Graphite pencils (also known as 'lead' pencils) are the most common and least expensive drawing tools around, and are basically a thin rod of graphite encased in a hollow tube of wood. They are graded from 8H (the hardest) to 8B (the softest), but the marks they make vary greatly according to the paper used. Normally the best drawings would combine many different grades, each exploiting the paper with their individual qualities.

Clutch pencils and propelling pencils are also available. These can be extended as necessary and so avoid the need for constant sharpening while you draw. Graphite sticks are used in a similar way to charcoal, and their butter-soft texture makes them great fun for large, bold drawings.

Other Equipment

It is always handy to have a good stock of papers so that you can choose the one most suitable for a particular drawing. Use a craft knife or a safety blade for sharpening pencils; inexpensive sharpeners are less than ideal as they tend to break the lead. For erasing, kneadable putty erasers are cleaner to use than Indian or pink pearl erasers.

Charcoal

Charcoal is the oldest drawing medium, dating from prehistoric times. Today, charcoal is made from carbonized vine or willow twigs and is sold in sticks of varying thicknesses and degrees of hardness. The softer, more powdery type of charcoal blends and smudges easily and is good for broad tonal areas; the harder sticks are best for linear details. Charcoal pencils are made from sticks of compressed charcoal encased in wood. Although much cleaner to use, you do tend to lose the 'feel' of working with traditional charcoal sticks since you can only use the point and not the side of the stick.

Other Equipment

Charcoal works well on papers with a matt, textured surface, such as Canson, Ingres or the less expensive sugar paper. As charcoal smudges easily, your finished drawings should be sprayed with fixative, which binds the charcoal particles to the paper surface. If you want to sharpen the point of a charcoal stick, use a scalpel blade or a piece of sandpaper. A kneadable putty eraser is useful for creating highlights in dark areas as well as for rubbing out mistakes.

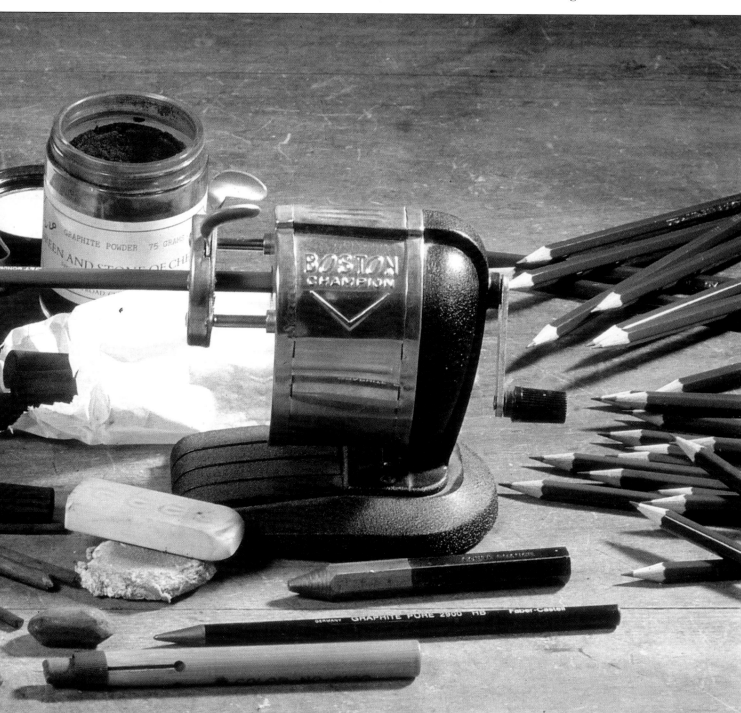

Techniques

GRAPHITE

Hatching

Solid tone and colour can be suggested in graphite using a series of parallel lines knows as hatching. This is perhaps the most basic drawing technique, and the one which most people would start to use naturally before moving on to others. By varying the weight and density of the hatched lines, a tonal variation from light to dark can be achieved easily and quickly. Straight, even lines produce a graphic effect while scribbled lines give a looser, more sketchy look. Different grades of graphite pencil and clutch pencil will give markedly different results. Graphite sticks, however, are only available in a few different 'B' grades, and consequently their marks tend to be rather similar. With the softer grades a hatched area can be lightly blended with the fingertip to produce textural variety. Hatched lines need not be straight; they can curve to follow the contours of an object, emphasizing its form.

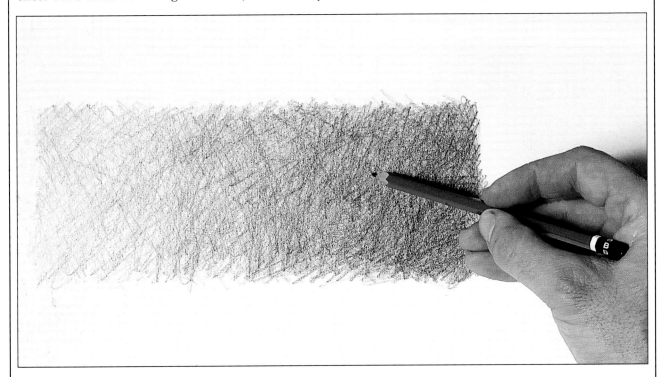

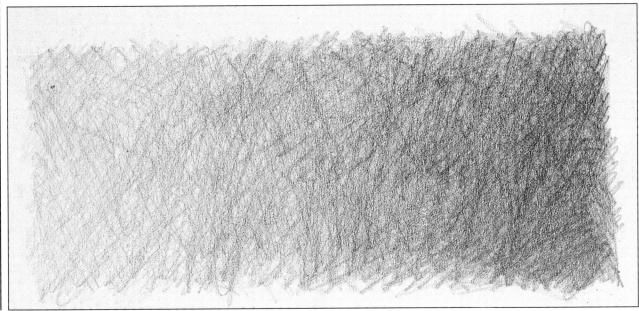

Crosshatching

This is a development of hatching, in which two or more sets of parallel lines are combined, one set crossing the other at an angle. Although originally developed for engraving, this technique can be used with all types of linear media, and some very interesting results can be achieved if you are prepared to experiment. As with hatching, graduations of tone can be achieved by varying the density of the lines: the more closely spaced, the darker the tone. The lines can be crosshatched at any angle you like, and even curved. Generally, freely drawn lines look more lively than perfectly straight ones.

In theory an entire drawing can be produced using crosshatching, but it is a labour-intensive technique. More often it is used in small areas of a drawing, its crisp, linear effect providing a textural contrast with the softer lines and shading used elsewhere.

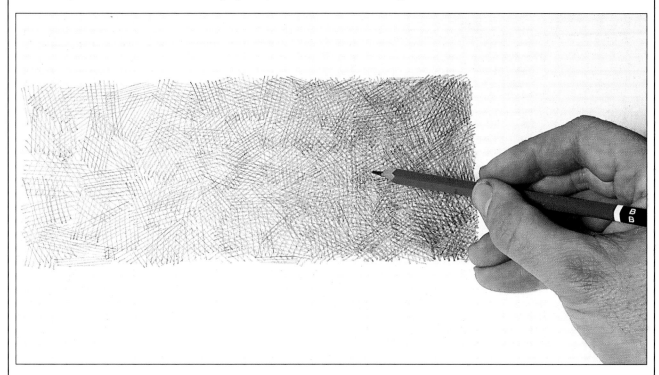

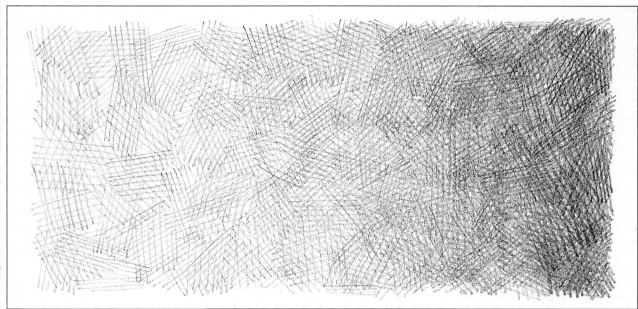

CHARCOAL

The beauty of charcoal is that it is so simple to use and it has a speed and spontaneity which lends itself to expressive drawing. It is the perfect medium for beginners and is nearly always the first medium introduced in art schools because it encourages students to think about the whole subject rather than getting lost in detail. Experiment with lines, varying the pressure to produce different thicknesses. Using the side of the stick gives a broad band which picks up the surface texture of the paper. The tip gives a solid black line with a smooth, flowing quality. For really fine lines, a sharp point can be obtained by lightly rubbing the end of the charcoal on a piece of sandpaper.

Tone

The most useful technique – as well as the most common – when using charcoal is to build up tone with a series of loose strokes (hatching). Draw yourself a small rectangle – which is purely to give yourself a restricted area when practising – and then start to fill it in slowly with loose, gentle strokes starting from one corner and finishing in the opposite corner. For darker tones you can work over from one corner again and again with the same loose strokes. Here it has been done twice to show how different the effect is between using *(1)* willow charcoal and *(2)* compressed charcoal, which is produced from charcoal powder pressed with a binding medium.

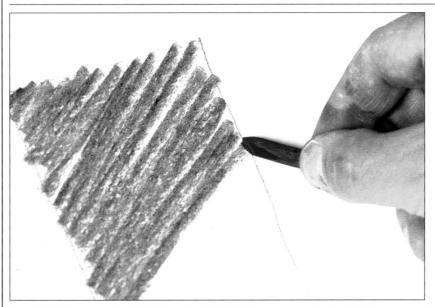

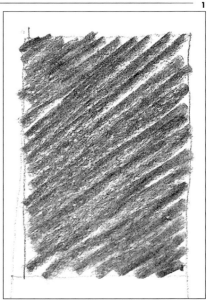

1

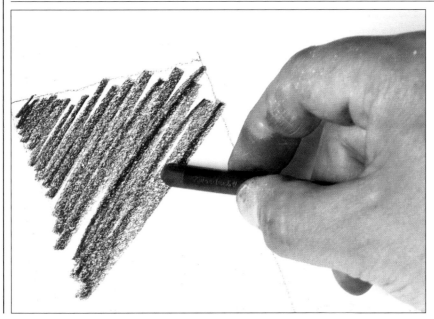

2

Soft Blending

The fact that charcoal is such a soft medium means that you can blend it with your finger to create a smooth, velvety effect. Again draw a small rectangle and then fill in one side with fairly solid black, using the side of the stick for speed. Then, with the tip of your finger, gently rub the charcoal to form a graded tone which has a lovely smooth finish. You can lighten the tone with further blending, or darken it by going over the area again with more charcoal and repeating the process.

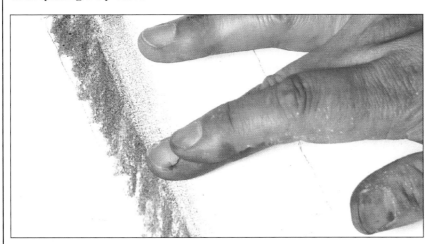

Highlights

To pick out highlights in a toned area you can use either a kneadable putty eraser or a stick of white chalk. Draw a small rectangle with the tip of the stick, and lay a fairly solid area of charcoal. Break off a small piece of the eraser and knead it with your fingers until it is warm enough to mould into any shape. To pick out highlights, pinch the putty to a fine point and use a press-and-lift motion without rubbing. To smudge or subdue the tone, rub gently with a round ball of putty. The putty can also be pulled across the charcoal – as shown here – to give a band of light through dark (1). When the putty becomes clogged with charcoal, discard it and break off another piece. An alternative to this is to use a stick of white chalk (2) and pull it down the paper in the same way. The real difference with chalk is that the highlights will be much sharper and a purer white.

1

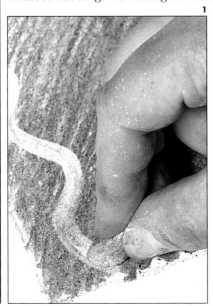

2

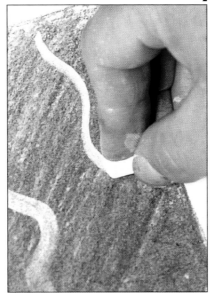

Silhouette

CHARCOAL

Although you cannot beat working with a live model, unfortunately we are not always in a position for this to be a practical option. Friends are often too shy and relations often too busy. You can pay a professional model, but this is not cheap. As an alternative, try your local art school or evening classes which will be less expensive. Television provides plenty of models and if you have a video you can freeze frame your chosen model in the position you want to draw. For our project here, we used a photograph from a newspaper which caught the artist's eye. Newspaper images are invariably soft-edged – due to the quality of the paper – and charcoal sticks produce an attractively soft line which can be altered in tone through pressure. When working in monochrome it is impossible to add highlights, so the way around this is to use the white paper by letting it show through the drawing. So you will need to work out at the beginning where your highlights will be.

1 Throughout this whole project you will only need to use one stick of large willow charcoal with one end sharpened to a tip with a razor blade. The paper is 120lb (260gsm) cartridge paper 23½x16½in. (60x42cm). With the fine end sketch in the basic shape of the head and all the outlines such as the collar and the lips.

2 Still using the fine end of the stick, add the eye and the ear. Switch round to the broad edge of the stick (the side) and add the basic areas of tone such as the hair, the back of the neck, the jawline and the shadows of the collar. Still using the side of the stick, lightly suggest the tone on the side of the chin and the lower neck.

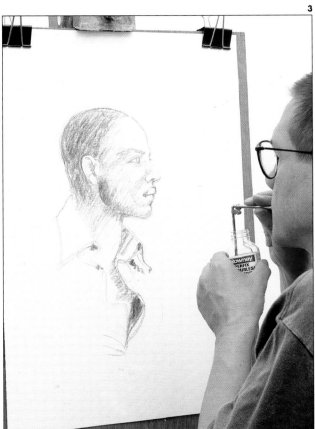

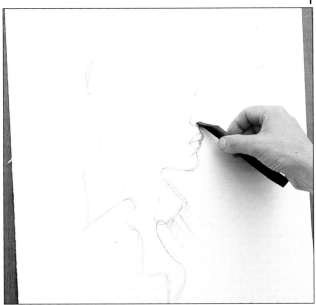

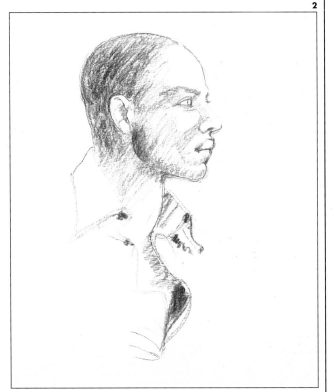

3 At this stage it is a good idea to fix the drawing. Here the artist is applying the fixative using an instrument that resembles a blow pipe, which is held in the bottle of fixative as shown. The advantage to this is that it cuts out all the terrible fumes which an aerosol (even a CFC-free one) creates. Fixing the portrait at this stage will allow you to superimpose sharper marks which will not be softened by the charcoal already on the paper. It also stops you smudging the work with your hand.

35

4

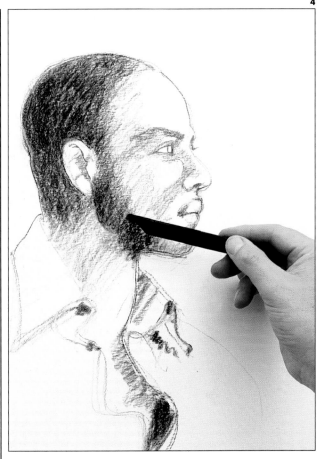

5

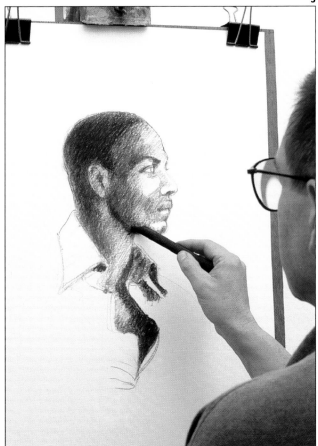

6

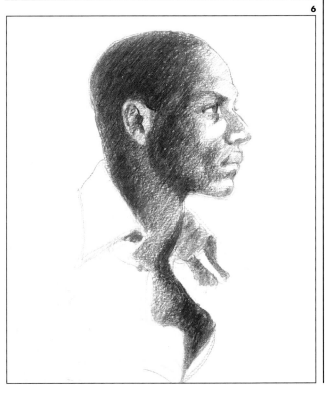

4 Using the side of the fine pointed end of the stick, which produces a sharper, blacker mark, add another layer of tone on to the hair. Now hold the stick lower down – which will give you a much freer stroke – and go over the hair and the side of the cheek again.

5 Continue by working up the dark line of the jaw, the cheeks, the shadows which fall under the collar of the shirt, the neck and the forehead. Do this by gradually building up the tone in layers and switching the stick from the fine end to the side to vary the strokes. At this stage fix the whole drawing again.

6 Work over all these areas once again gradually building up the darks. Refer back to the reference and when you are happy with the result move on and add all the finer details of the face. Using the side of the pointed end of the stick, start to work up the mouth and the shadows around the nose. Whilst working on the nose switch to the tip of the stick and re-define the outline of the nose to accentuate its contour. Move back to the side of the point and go over the darker areas once more. Switch back to the point and tighten up the lines of the inner ear and eyes and deepen the lines under the eyes and eyelashes.

7 Before any further work is done, fix the whole drawing again to avoid smudging. Using the wide edge of the charcoal, add the shadow on the collar and go over the larger areas of shadow again. With the pointed end of the stick suggest all the smaller, finer details such as the eyebrows and the contours of the inner ear.

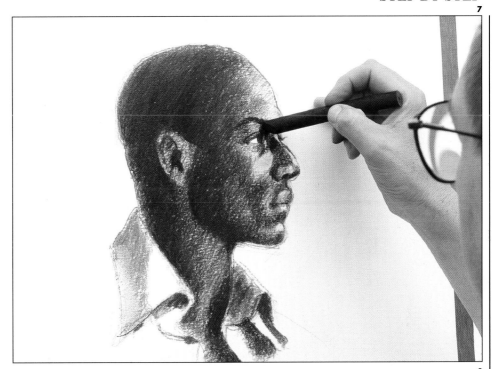

8 If you do not mind getting messy, smudge the charcoal over the highlighted areas with your finger tip to blend them in with the rest of the picture and soften the edges; otherwise you can use cotton wool. Now fix the whole drawing again.

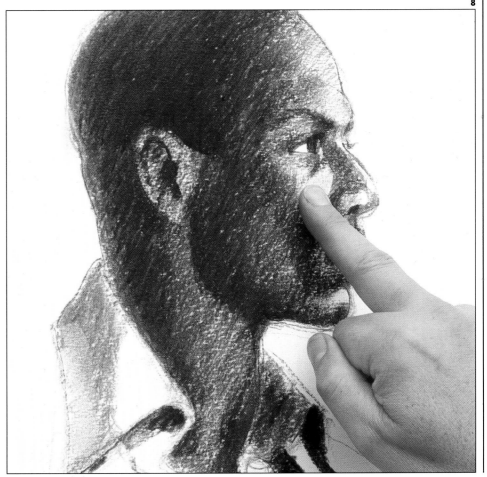

CHARCOAL / SILHOUETTE

9 When the fixative has dried, go over the dark areas once again using fairly loose strokes. You can use either the side of the stick or the pointed end, which should be well rounded by now. At this point you may want to neaten up the edge of the nose if it is looking a little untidy.

10 Because some final adjustments are needed in the details, sharpen the end of the charcoal stick again with a razor blade. Break a small piece off a putty eraser and roll it into a point and use it to go over the portrait picking out the highlights. Now go over the dark areas once again. Add the two dark areas in the eye socket and on the side of the nose, picking off the lighter areas with the 'mini' eraser. Darken the eyebrow and generally tidy up the whole picture, tightening details where necessary.

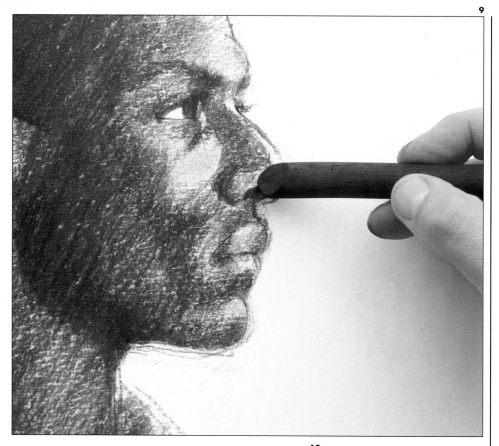

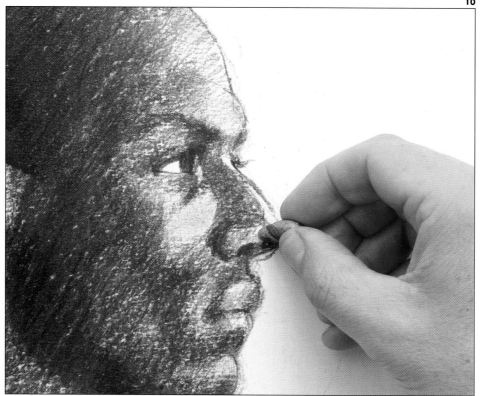

10

11 One more vital thing before stepping back to admire your work, or moving it, is to spray the whole drawing with fixative. It is amazing how many people forget to do this and end up with just one large smudge across the paper. So be warned.

Back to the subject of the drawing, we hope that you have enjoyed working in charcoal and the freedom and the speed that a single stick can give you. Although here we have worked up this portrait to a highly finished state, you can also achieve some dramatic results by employing much looser, bolder strokes.

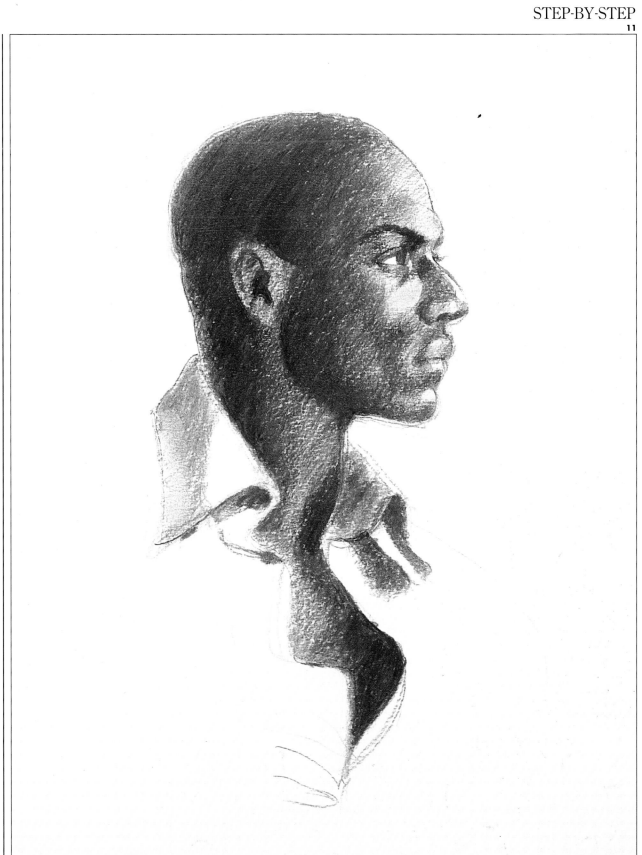

Self Portrait

GRAPHITE PENCIL

Probably the most testing yet approachable type of portrait is the self-portrait. This is because the artist can concentrate on the characteristics (not only the obvious outer features but also the more subtle 'essence' which sums up a person) without having to cope with the 'separateness' of another person. In addition, for the beginner especially, the self-portrait uses the most perfect of models who will never get tired before you do!

The way you position yourself for a self-portrait is very important. You need your paper as upright as possible to avoid foreshortening and you also need a mirror at face height set up so that you can see yourself without having to get up. The size of the mirror is largely irrelevant, but you may find it helpful to use a small one which will concentrate your attention. For this project the artist included the mirror in his drawing to accentuate the 'self-portrait' aspect.

Select a pose which arrives naturally when you look from the paper to the mirror (in this case with the head slightly turned to one side). By doing this you will be able

to switch from your reflection to your drawing with the minimum of effort.

For this self-portrait, various graphite pencils, some harder and some softer, are used. The result, however, is not a sketch but a finished drawing, concentrating on the modelling of the form without the complication of colour.

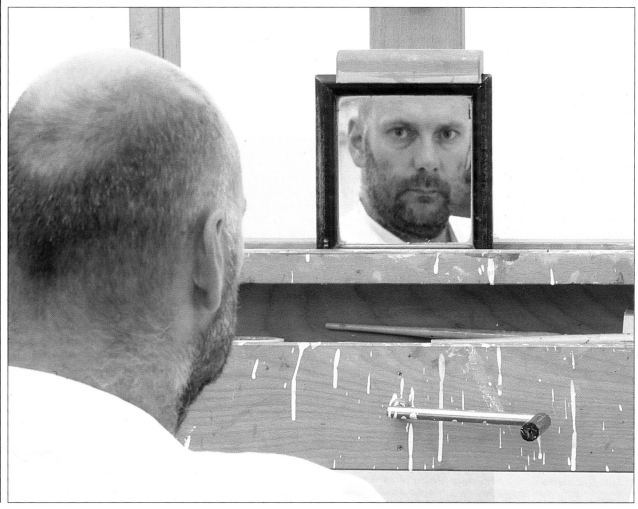

1 Start roughly in the centre of a 30x22in. (75x56cm) sheet of drawing or watercolour paper by marking in one of your eyes with an HB graphite pencil or stick, switching to a softer 3B for creating areas of darkening tone. By starting in the centre of a large sheet of paper and with a central point on your face, you can work from this point, relating back to the eye. In this way, with constant reference back to your own reflection, you are more likely to get the proportions right.

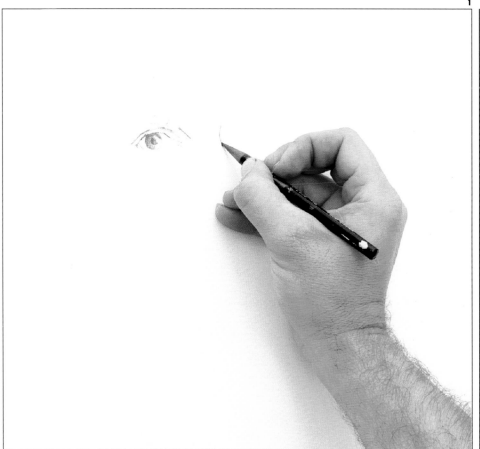

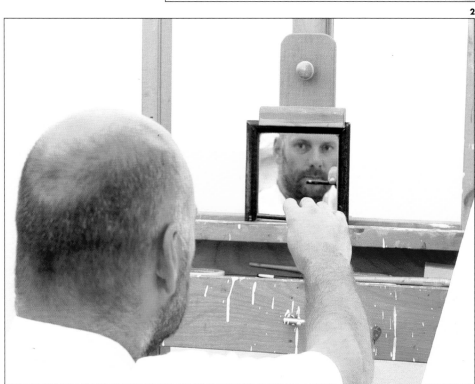

2 With this type of work, it is helpful to use your pencil to measure the proportions as you go. If you hold your pencil at arm's length – or at a constant distance from the mirror if you are too close – you can measure crucial distances (such as the space between the eyes) with your thumb along the pencil. You then transfer this measurement to your drawing.

3 It is important to pay special attention to your eyes as they hold so much of the character. Take your time, working with small strokes and gradually building up the area around them.

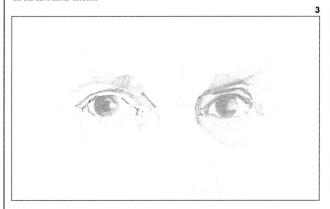

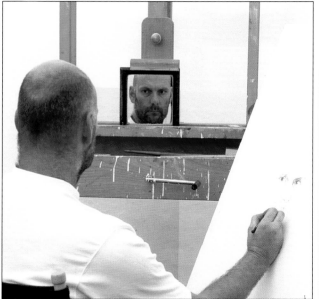

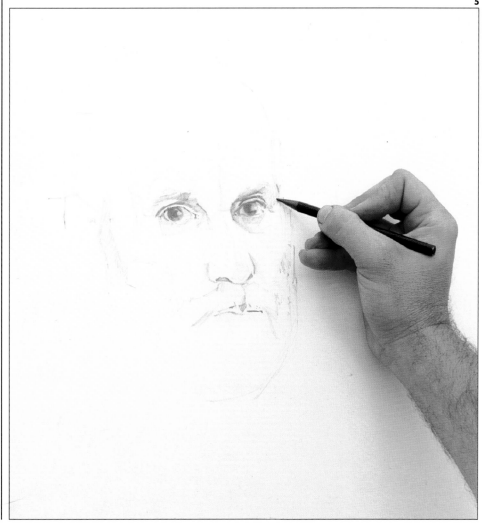

4 From the eyes, the logical way to work is down the nose to start to define the length of the face. You can then begin to outline loosely the limits of the head. Feel free to use an eraser if you think that any of the marks are too strong or in slightly the wrong place. A putty rubber is generally the best type of eraser to use as it does a good job of lifting the graphite without damaging the surface of the paper.

5 Once the whole form has been established you can start to work up small sections at a time using a combination of loose hatching and cross-hatching. Allow yourself to move around the drawing freely, switching from feature to feature, and so preventing the overworking of any given area. In addition, by building up the picture as a whole, it is far easier to see if there are any problems. If there are, it is far easier to correct them early on.

6

6 If you are working with a small mirror which frames your head well, then it can be very useful to include the mirror in your drawing as it will readily show whether you have drawn the proportions of your head correctly – i.e. too tall or wide.

If you do not wish the mirror to appear in your drawing you can still lightly mark in its outline at this stage to check the proportions. Simply rub the marks out later on with an eraser.

7

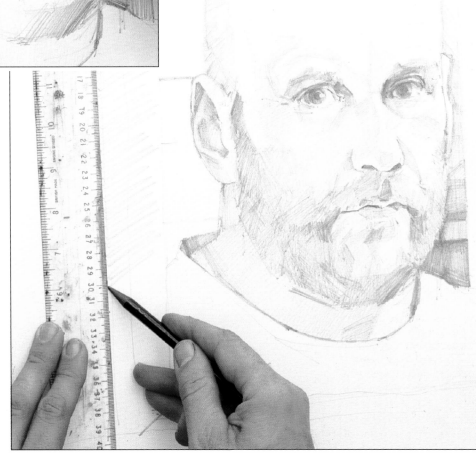

7 The mirror in this case has a dark frame, which is ideal for the drawing as it helps to pull it together. To get a crisp line along the edges, hold a ruler up against the paper and hatch against it with a 3B graphite pencil or stick. By hatching more on one side of the frame than the other you will create a curved effect, which can be further enhanced by using a putty rubber to pick out a highlight along its length.

8 As you work it will become obvious which areas need to be darker or lighter. You can suggest large areas of fairly flat tone with a very loose hatching motion, almost laying the pencil flat on the paper to give a much softer mark.

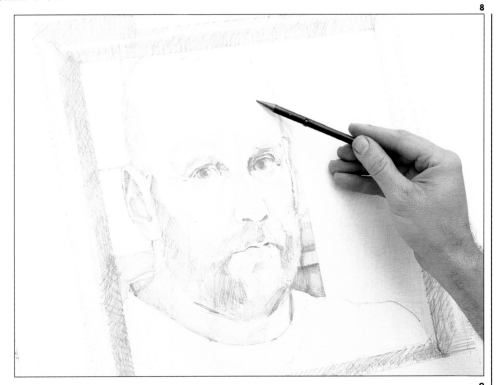

9 Once you are happy with your drawing, put the highlights in place to finish it off. These are loosely suggested by dragging a putty rubber over the appropriate areas. As an alternative you could have left the white of the paper showing through to give crisp highlights, but this is much more time-consuming as you have to carefully work around them and, as this is a drawing in a mirror, crisp highlights would spoil the 'reflected image' effect.

10 Finally, to further accentuate the fact that this is a drawing of a face in a mirror, rather than a framed drawing of a face, vague 'slivers' of light need to be added over the surface of the mirror. Again, this is simply done by gently dragging the putty rubber over the surface of the drawing in wide sweeps. Make sure you keep the pressure on the eraser light as you do not want to ruin your finished masterpiece!

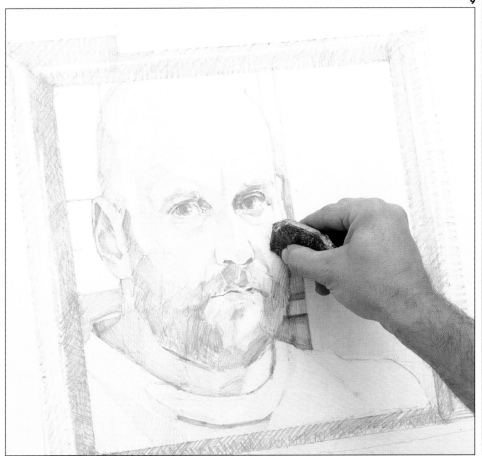

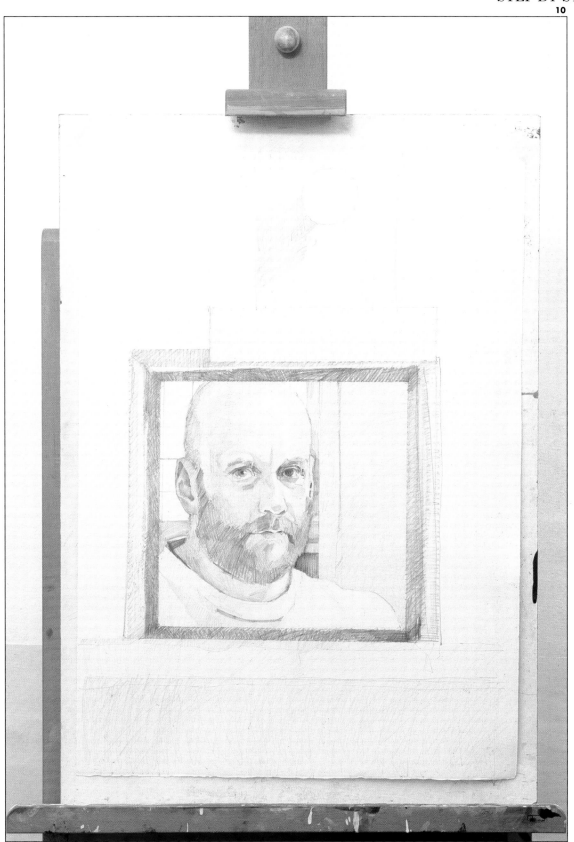

Chapter 4
Dry Colour

In the previous chapter we started you off with projects that did not involve colour, but were aimed at improving your basic drawing techniques. Now we are going to progress on to the next stage, which employs drawing but in colour. This is the meaning of the term 'dry colour'. It can be used when referring to any medium which is capable of producing a coloured drawing, but we have chosen pastel and conté pencils for the two projects here. These media will present you with two totally contrasting ways of working.

Conté has been around for years in the form of crayons, or sticks. In this form it can be used in a similar way to pastels and was utilized by many famous artists, including Toulouse-Lautrec. However, in more recent years the sticks have been encased in wood, which makes them appear more like coloured pencils. The similarity stops there because conté is so much softer and chalkier. Therefore you have the advantages of a soft medium, constricted in a case, which in turn means that your approach will have to be tighter.

Pastels, on the other hand, are exceptionally versatile and may be used as a drawing or painting medium. They have been a great favourite with artists for many years, and first became popular with the French Impressionists. Pastels lend themselves to a spontaneous, easy style that is rather similar to charcoal, which makes them ideal for an introduction to colour work.

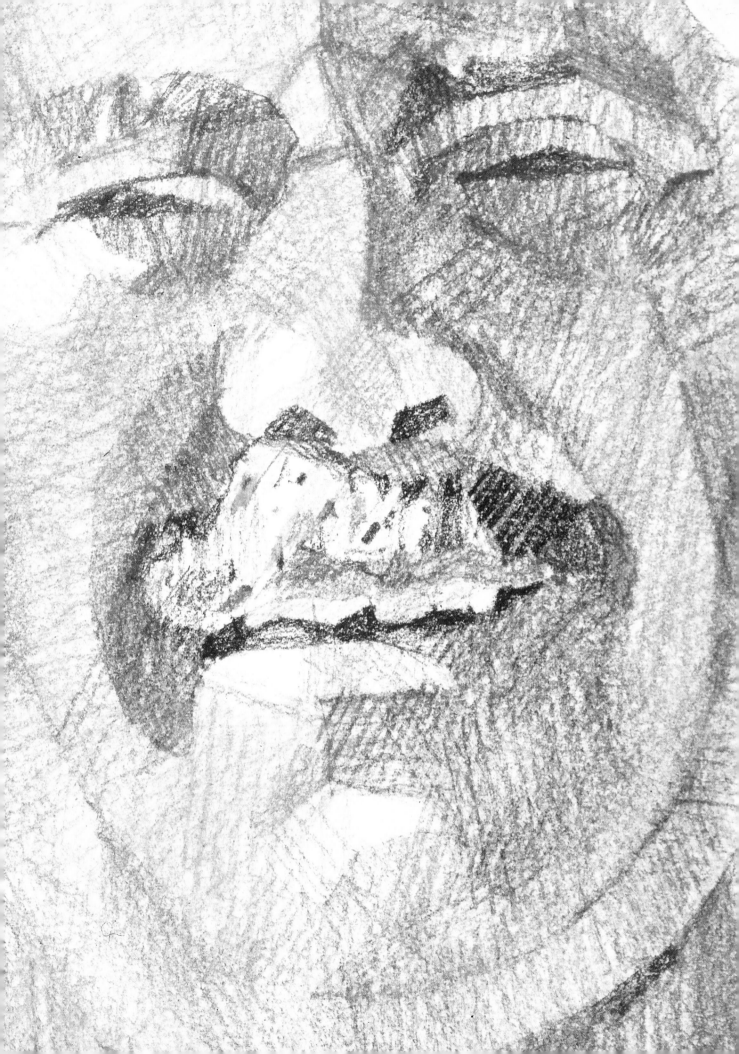

Materials

CONTÉ PENCILS AND PASTELS

Conté Pencils

Traditionally, conté was only available in the form of oblong sticks and in a restricted colour range of black, white, grey, sanguine, sepia and bistre (earth colours). Nowadays they are produced in a wide range of colours and – like pastels – are also available in pencil form.

Conté pencils are made from pigment and clay bound with gum, which is then pressed into rods and encased in wood. They are softer and less waxy than ordinary coloured pencils, but not as soft and crumbly as pastels. Because they can be sharpened to a point, they are ideal for detailed linear work – and are less messy to use than conté crayons. As with coloured pencils, they can be bought individually by the stick or in boxed sets of assorted colours. This is useful as it enables you to start out with a basic set and then add to it as the need arises.

Pastels

Pastels are made from pure pigments and chalk bound with gum and moulded into square or round sticks. They come in three grades – soft, medium and hard – the soft grade containing more pigment and less gum. Soft and hard pastels each produce a different range of textures and effects, and the two types can be combined quite happily, and to good effect, in the same painting.

The nature of pastels does not allow you to physically mix the colours, so they are available in every hue and shade under the sun. This can make it difficult when you come to choose which colours you need, but you can buy boxed sets of assorted colours. Some of these even comprise selected colour ranges covering specific subjects such as landscapes, portraits and still life, which should help you immensely. Be warned though, they are exceptionally messy to work with.

Oil pastels have an added binder of oil, so they are not as crumbly as pure pastels and do not smudge excessively. Instead of a soft velvety texture, oil pastels make thick, buttery strokes. They respond rather like oil paints, so you can work into them with a brush dipped in turpentine for a wash effect.

Supports

When working with pastels or conté pencils remember that the colour of the paper will play an important part in your finished picture. This is because dry colour sticks are worked loosely and sketchily rather than in solid blocks of colour, therefore the colour of your support will inevitably show through in some areas. So try to choose a tinted paper which either harmonizes with your subject or provides a contrast.

Because of their slightly powdery texture, pastels require a paper with enough texture, or 'tooth', to hold the pigment particles in place. Ingres paper is perhaps the most suitable as it is available in a wide range of colours and has a rough surface. In fact any paper that has a textured finish – even fine sandpaper – can be used. Conté pencils, being less powdery, can be used on a smoother grade of paper.

Other Equipment

When working in pastels you will need to spray your work with fixative to bind the pastel particles to the paper and protect it from smudging. Another handy tool is a large, soft brush to brush away any excess dust which is invariably left when working in such powdery medium. A torchon (a stump of rolled paper) is useful for blending pastel colours, though a rag, cotton bud (Q-tip) or your fingertip would do the job just as well. Finally, you will need a scalpel or craft knife to sharpen the points of conté pencils and pastel sticks.

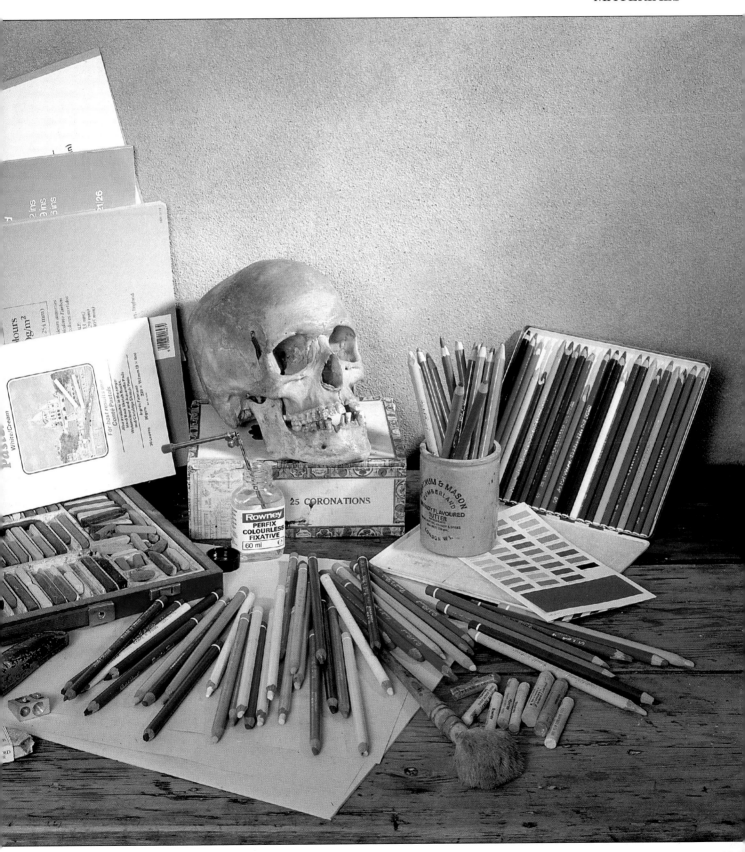

Techniques

CONTÉ PENCIL

The beauty of conté pencils lies in the infinite range of colours you can achieve through optical mixing. When working in conté pencils colours cannot be physically mixed together on the palette as they can with paints, but a whole range of colours can be achieved through optical mixing – laying one colour over another. From the appropriate viewing distance these colours appear to blend together, but the effect is more vibrant than an area of flat colour because the strokes are broken up.

Crosshatching

As we explained in the graphite pencil techniques section (page 31), crosshatching is where two or more sets of parallel lines are combined, one set crossing the other at an angle. With conté pencils this can be taken a stage further and used as a way of optically mixing colours in a very clean and crisp way. It is important when using this technique that your pencil is always sharp *(1)* and this is best done with a craft knife or sharp blade.

Carefully crosshatch over the entire area with one colour and then crosshatch over it in another colour *(2)*. Apart from creating an interesting textural effect *(3)* the overlaid strokes produce colour mixes where they intersect with each other.

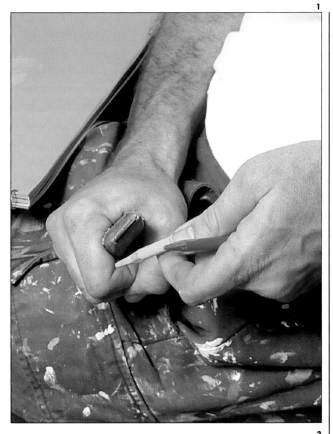

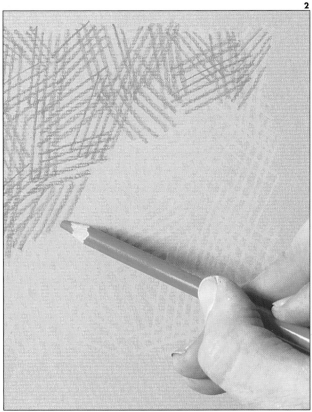

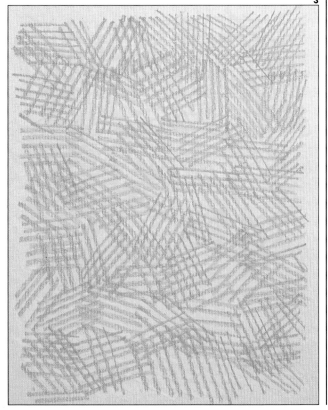

Pointillism

Pointillism is a way of building up an area with small dots of pure colour and comes from the French word *point* meaning dot. The dots are closely spaced, but not joined, allowing some of the toned paper to show through. Start in one colour and fill the area with dots. Change to another colour and add more dots to the spaces left by the first colour. From a distance these dots appear to merge into one mass of vibrant colour. However, it is important to note that this vibrancy is only achieved when the colours are of the same tone.

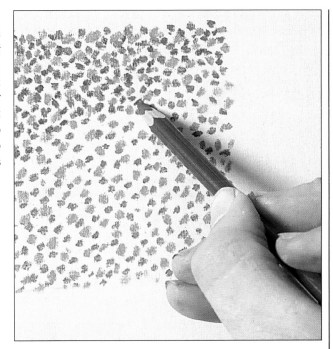

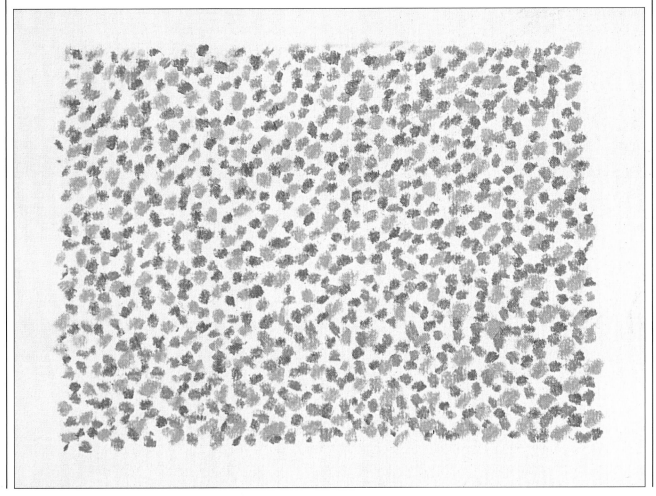

PASTEL

Linear Strokes

When taking up pastels for the first time it is important to practise the various strokes that are achieved by using the stick in different ways. Although the pastel used in these examples is a special hand-made type which is much fatter than the normal, commercially produced varieties, the basic strokes are identical. Using the pastel on its side *(1)* produces a broad band of colour which is perfect for filling in large areas. By running the edge of the stick down the paper *(2)* you get a thin line of dense colour. A flat end of the pastel *(3)* produces a band of colour as thick as the pastel. Finally, by sharpening the pastel to a point *(4)* you will get a very thin, sharply defined line.

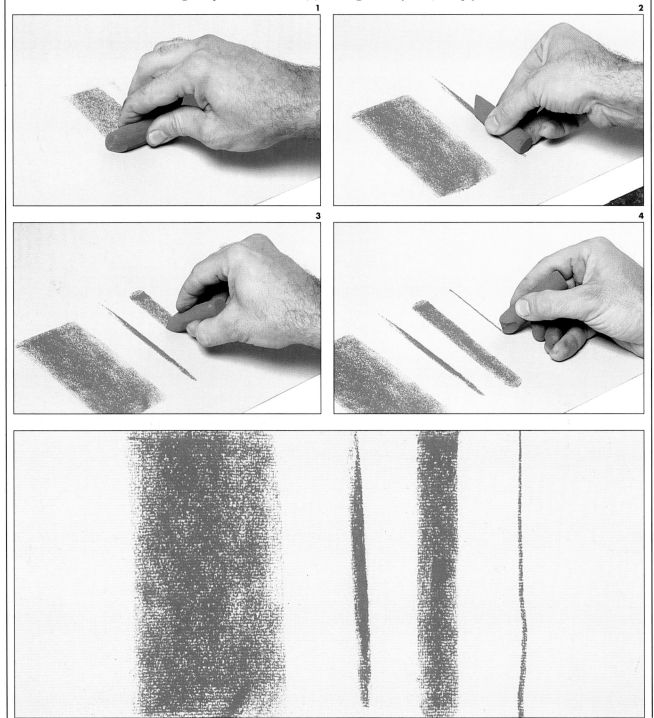

Scumbling

Scumbling is a term used to describe the technique of mixing colours optically by laying one colour over another. Start by laying a loose tone of colour from the left-hand side, then change to another colour. With this second colour begin from the right and continue until it crosses over the first colour. Where the colours overlap they mix, giving the illusion of a third colour.

Blending

As you can see from the previous technique, when one pastel colour is drawn over another they will naturally blend on the paper to form a mixed colour. In reality this is optical mixing, but it is on such a fine scale – as the particles of pastel colour mix together – that it appears to be an actual mixing of colours. To blend pastels further, loosely scribble in an area and then change to another colour. As you cross over you will find that it picks up and blends with the colour underneath. Now gently rub over the area with your finger, a torchon, a brush or a piece of tissue to merge the two colours. This technique produces a subtle and smooth transition of colour.

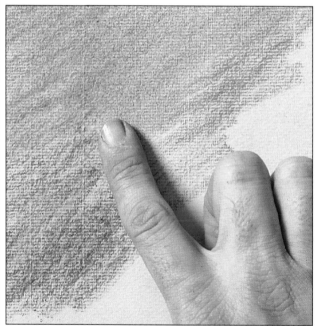

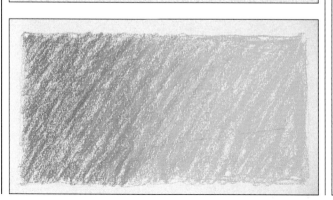

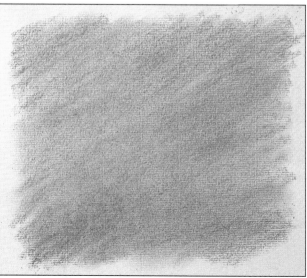

Egyptian Man
CONTÉ PENCIL

Sometimes you will come across people who just instantly strike you as good subject-matter for a drawing or painting. In this case the artist was on holiday in Egypt, exploring the ancient monuments and generally soaking up the sights and sounds when he chanced upon this friendly fellow wearing the traditional *galaba* (smock) and turban. Although, as is common in many tourist spots in poorer nations, the man required money before he would pose for a photograph, it was (literally) a small price to pay.

It is preferable to work from life, but photographic reference can prove invaluable in a case like this. A hasty sketch could have been done at the time, but by taking photographs a much more considered approach is possible. However, to give the feel of a sketch done on the spot, conté was the chosen medium for the portrait carried out back home. This is because many artists do in fact use dry colour media such as conté and pastels to carry out sketches when working outdoors as they are, of course, colourful as well as clean, easy to carry and without the paraphernalia associated with some media.

When working with any coloured drawing medium the first thing you must consider is your paper – its type and colour. Your choice, of course, will depend on what you are trying to achieve. For a loose, sketchy picture you want a rough paper to break up the stroke. However, for this piece you will be hatching in places, and so you will need a paper with a smoother surface. The colour of the paper also affects the finished drawing. You can either go for a plain white paper (as used here) and let the drawing stand out against it, or use one of the vast range of tinted papers. However, make sure you select a colour that will complement your work. It is also useful to use a tinted paper in a creamy shade as the base tone for the skin. This makes it easier to model the face, adding shadows and highlights on to the base tone.

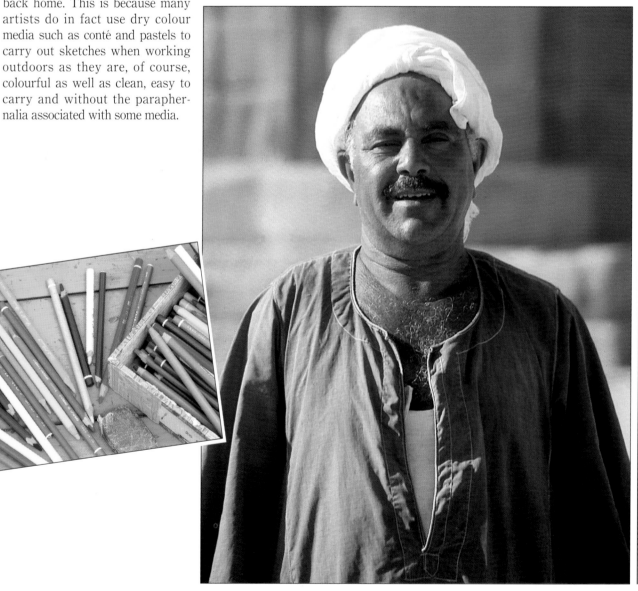

1 Start the drawing by marking out the main areas of the composition using a very dark grey for the darker outlines and a red/brown for the lighter areas of the face. Keep your initial marks faint as you copy from the reference, re-establishing the marks once you are happy with the general proportions. If you do not feel confident with working by eye, then you can enlarge the reference picture on a photo-copier and simply trace over it.

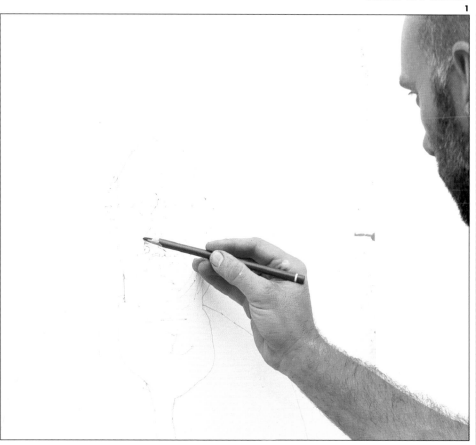

2 Continue with these two conté pencils to establish all the very darkest areas such as the eyes, inside of the mouth and nostrils. Then use just the red/brown conté to hatch in the main shadow areas.

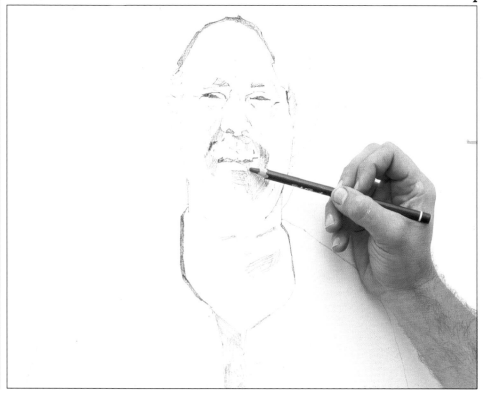

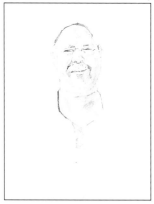

3 Once the shadows have been established you can start to work on the mid-tones of the skin, hatching with a dark orange. Crosshatch over the darker mid-tone areas, and likewise crosshatch some light red over most of the orange. Keep your hatching very open (with lots of space between the lines) so that the colour beneath can show through.

4 Now work in further dark brown over some of the more shadowy areas you established in steps 2 and 3. Again use a loose hatching so that the colour underneath can show through.

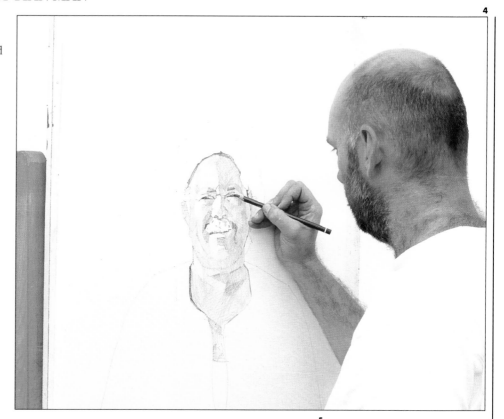

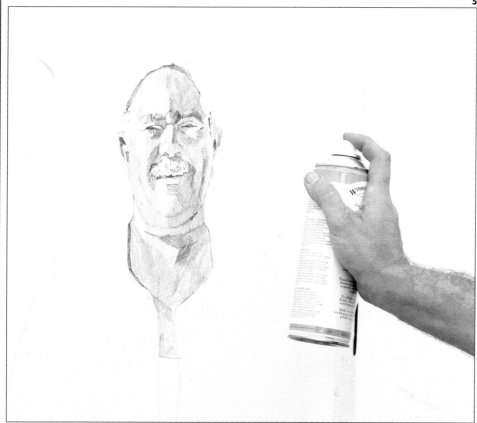

5 Now that the basic features are in place, you must spray your picture with fixative to make sure that these initial marks retain their quality of line even after further conté hatching is superimposed. Wait a few minutes for the fixative to dry before starting work again.

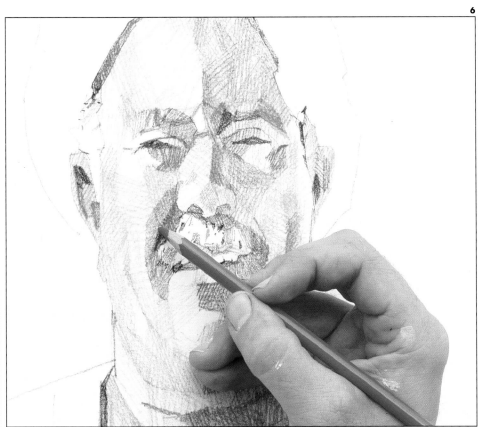

6 To help give the drawing plenty of 'punch', you will need to introduce some strong colours. The deep shadows in the skin tones are the perfect place to do this as the strong colours will have a presence without being too obtrusive.

Start on the shadows by loosely hatching over some of them – for example the deep furrows that run from nose to mouth – with a dark red.

7 You can also use a strong blue – the nearest conté equivalent to cobalt blue you can find – to loosely hatch over the shadowy areas in the flesh. The blue element in skin tones is particularly evident in shadows.

Continue the process of building up the skin tones by going over them with red/brown, orange and light red with a very open hatch. Then spray the drawing with fixative again.

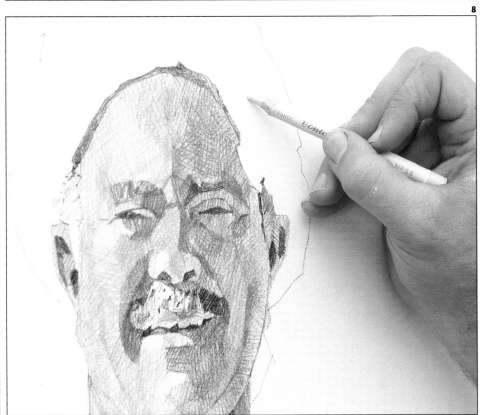

8 Now switch your attention to the turban for a little while so that the drawing progresses as a whole. With a very pale blue lay a tight hatch (lines close together) to indicate the shadows in the folds of the turban.

9

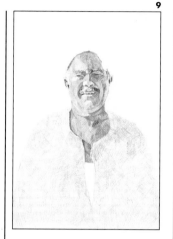

10

9 Once the fixative on the man's face has dried you can return to subdue the shadow tones slightly by laying an open hatch of brown over them. The bold red and blue tones will still be evident, but the brown has the effect of knocking them back.

Switching once again away from the man's face, use a blue/grey conté pencil to lightly block in the *galaba* – the man's smock – with a combination of loose hatching and crosshatching.

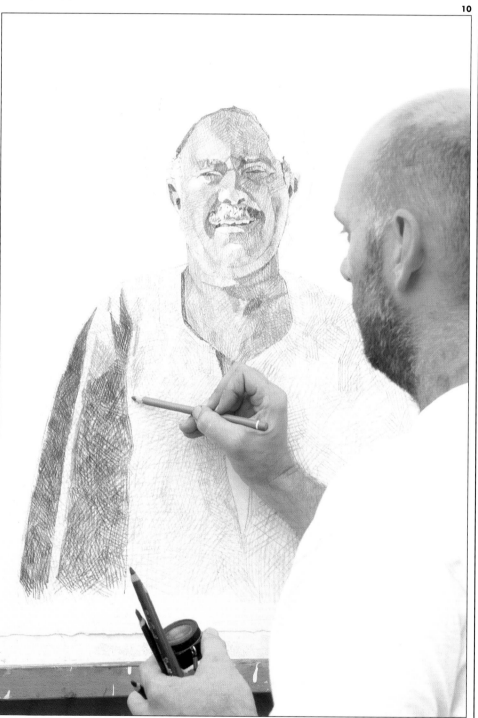

10 Finally, to finish the picture, bring out the shadowy folds on the *galaba* with a crosshatch of black, purple and red. Then switch to a mid blue to add gentle hatching around the shadows to suggest the mid-tones.

11 Stand back and give your drawing an all-over appraisal. If any areas require further work, now is the time to do it. Perhaps the shadows could do with being a little darker, or you may feel it necessary to add some highlights with white conté on the face. When you are finally happy with the drawing, spray it with fixative to prevent any chance of it becoming smudged.

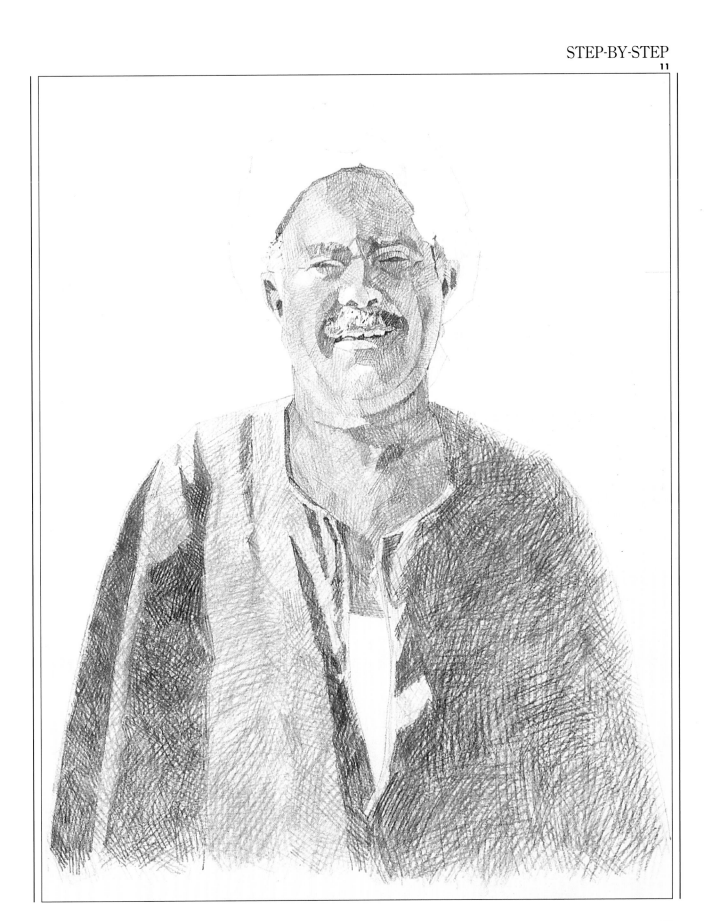

The Couple

PASTELS

The two models in this double portrait were of very different heights. When they were standing next to each other the man's head was so far above the woman's that the painting did not have any focal point, making it difficult for the viewer to concentrate on any one part of the image.

To overcome this problem, we decided the woman should stand and the man sit; as you can see, this arrangement works much better. By turning the man's head to the side, we then achieved a portrait which included a 'face on' and a profile, adding even more interest to the composition.

Pastels are extremely versatile, and although they are renowned for being a 'fast' medium, they can also be used to produce a more finished work in a fairly tight way of working. For this project we have tried to aim for a mixture of these two styles, taking the faces to a higher state of finish than the rest of the portrait. The important thing is to take care not to overwork your picture or you will lose the vibrancy and expressiveness which makes pastels such a joy to use.

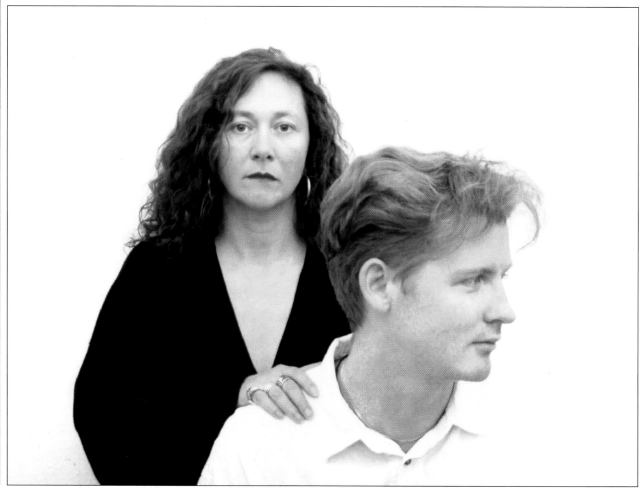

1 For this project we used a grey tinted drawing paper with a rough surface measuring 20x15in. (51x38cm). Grey provides a good base tone to work from for both light and dark colours and will not create a harsh contrast for the background. The initial drawing is sketched in orange, which is visible and yet will not overpower the portrait as it appears in the final piece.

2 Throughout this project we use a mix of red and dark green to suggest the darker tones. This is more subtle in the shadows of the face and hair and more obvious on the woman's top. So, with dark green, loosely cover the area of the woman's black top, then go over it again with red in the same fashion. This, as you can see, gives the effect of black – but it will be a deeper, more 'living' colour, by having been produced from overlaying the colours.

3 Continue with the red and sketch over the woman's hair and some areas of the man's hair. This is done over both, even though the hair colour is different, to create a sense of unity. Switch back to the dark green and go over the black top again to darken it a bit more. Now, with a pale lilac, go loosely over the man's shirt, the neckline of the woman and lightly over the background to keep everything in harmony. Now – again loosely – go over the shirt and the background in pale blue.

4 Returning to the faces, start work on the shadows using the red and green formula. Start with a bright red to model the details of the woman's face, such as the eyes and the lips, as well as the outline of the hair. Smudge the red under her chin with your finger to soften the edges and create the shadows. Switch to dark green and go over all the really dark areas again. The red showing through and around the green softens these darker tones, which is why the face is built up in this way.

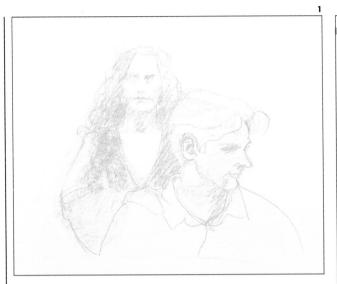

5 Now for the background, which is a white wall. First hatch over it with some white and then introduce a variety of pale colours to the background: pale green, pale yellow, pale pink and pale lilac worked into the white. This will liven up the wall and avoid it from becoming a flat white.

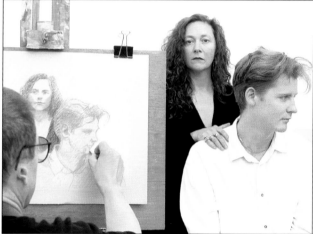

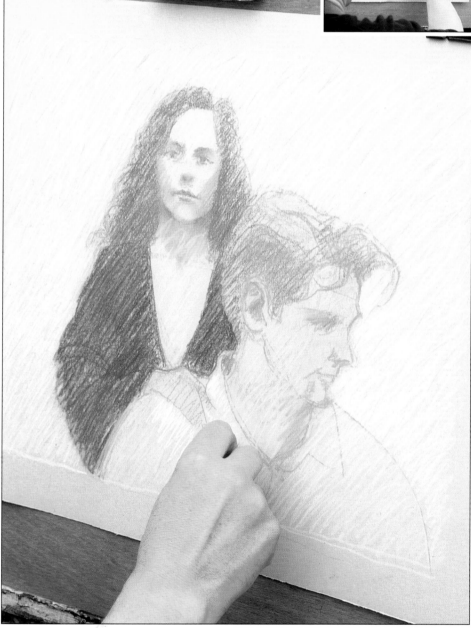

6 Start to go over the man's white shirt in white including the collar. Now draw a rough frame around the image which will give you a self-imposed border to work within. Cut in with the white around the man's face, which will sharpen the contours of the face and make it stand out against the background. Then go over the whole of the background, starting at the top with clear strokes which get weaker at the bottom. This will make the background appear darker at the bottom where the grey shows through more and suggests light from above. When you have completed the layer of white over the background, fix the drawing.

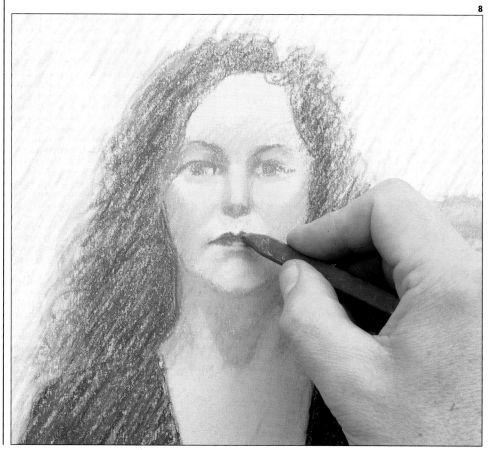

7 Although we use a 'blow pipe' to spray the drawing with fixative, a CFC-free aerosol is just as good. If you cannot get to an art shop, hair spray is a useful alternative. Whilst waiting for the fixative to dry, step back and take an overall view of your drawing and plan your next step.

8 Go over all the darkest areas once more in the dark green before starting to model the facial features with a pale and a medium flesh tint. Change to a reddish brown and redefine the woman's eyes, nose and eyebrows, softening the edges by gently smudging with your finger tip as you go. Moving over to the man, adjust his hairline with a pale flesh tone, then switch to the reddish brown for the contour of his nose. Continue to model the nose by alternating between the pale flesh and the reddish brown. With the medium flesh tone, work up the side of the nose and the shadows on the chin and lips. Go back to the reddish brown to go over the man's hair and the shadow cast by the shirt collar on the bottom of his neck. Returning to the woman and sticking to the reddish brown, add the outline of the lips and then fill them in before going over her hair to deepen its tone.

9 Now alternate between the pale and the medium flesh tints and continue to model the woman's eyes and nose, then with the medium flesh tint work up the chin.

At this stage it is useful to look at the models objectively and check on your likeness. In this case the woman's face appeared to be too broad, so alternate between the reddish brown, medium flesh and pale flesh tint to redefine the shape slightly. With cream and then white add the earring and the highlights to the woman's face. Using the same two colours model the man's face. With the dark green, add depth to the hair and then redefine it with reddish brown. Add the highlights with a mixture of pale lilac and cream. Accentuate the creases of the shirt with a layer of white, leaving the base colours to show through to form the shadows.

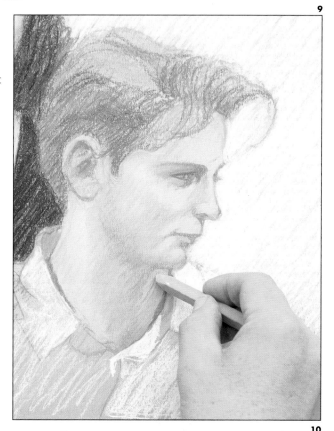

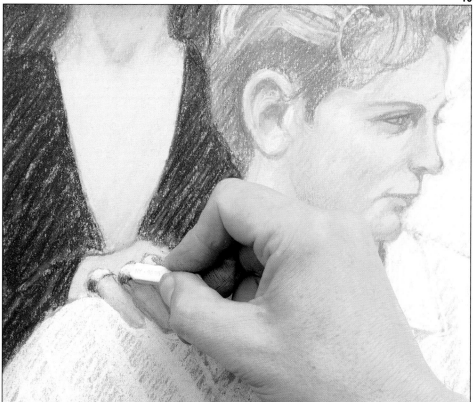

10 Moving on to the woman's hands, outline the fingers in the medium flesh tone. Change to the white and go back over the shirt, giving it a final tidying up. Work up the man's ear with the pale flesh tone switching to white for the highlights. Smudge the ear gently with your finger tip to soften it and tighten up its outline with the reddish brown.

Outline the girl's hand with the medium flesh tone and highlight with the pale flesh tone, running the reddish brown between the fingers. Moving on to the rings, fill them in with dark green and define the outlines in reddish brown before going over them in white to show the reflective nature of the metal.

11 Now it is just a matter of stepping back to take an overall view of the composition to see whether or not any final finishing touches are required. This will differ from person to person but in this case it was obvious that the highlights needed to be emphasized with more white.

Having completed the gruelling task of keeping still for so long the moment arrived for us to see the final piece. We felt that it was very flattering, but the artist was keen to point out that it was only his interpretation and that another artist's finished piece could be completely different. Of course, this applies to every painting that you do. On the practical side, the artist's final word is to refrain from fixing the image all over at the end as this will change the tones and the white areas will disappear. Either fix near to the end and then re-establish the highlights or just fix the dark colours. When you come to store this portrait, therefore, you will need to protect it carefully with tissue or tracing paper and pack it flat and preferably in a place where it will not be moved around.

11

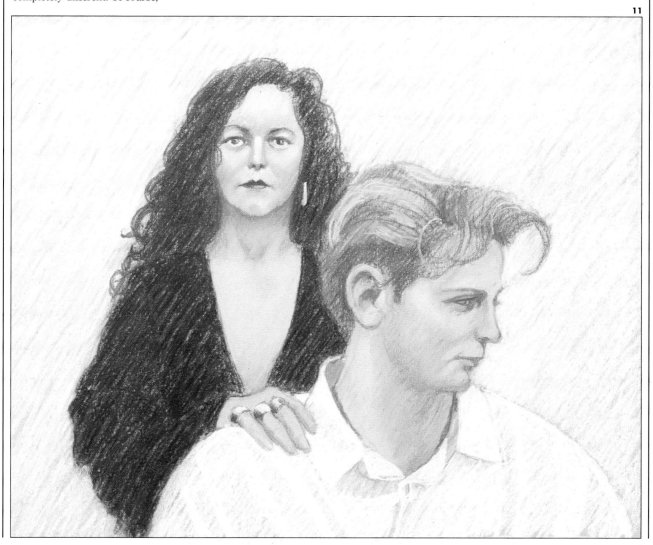

Chapter 5
Watercolour

In this chapter you are finally going to experience the thrill of using real paint. Although you will have gained some knowledge about working in colour from the previous chapter, it must be said that dry colour does not really possess the versatility and range of effects that are possible when working with paints. In addition, 'wet' colours can be physically mixed together on the palette to create an infinite range of hues, whereas dry colours can only be mixed optically, on the paper.

Pure watercolour is perfect for applying thin, translucent washes of colour on white paper. Gouache, an opaque form of watercolour, is better suited to laying flat, opaque patches of colour. With gouache, the translucency of pure water-

colour is lost, but it has the distinct advantage of allowing the artist to work from dark to light, building up from the shadows to the highlights. A particularly enjoyable approach is to combine both pure watercolour and gouache in a painting and exploit the best features of both.

Although watercolour has the reputation of being a difficult medium to master, the basic techniques are really very simple. Most beginners fail because they rush into the business of creating a picture without first getting to know how the medium behaves and what it is capable of. Take your time practising the basic techniques at the beginning of this chapter, before moving on to the step-by-step demonstrations.

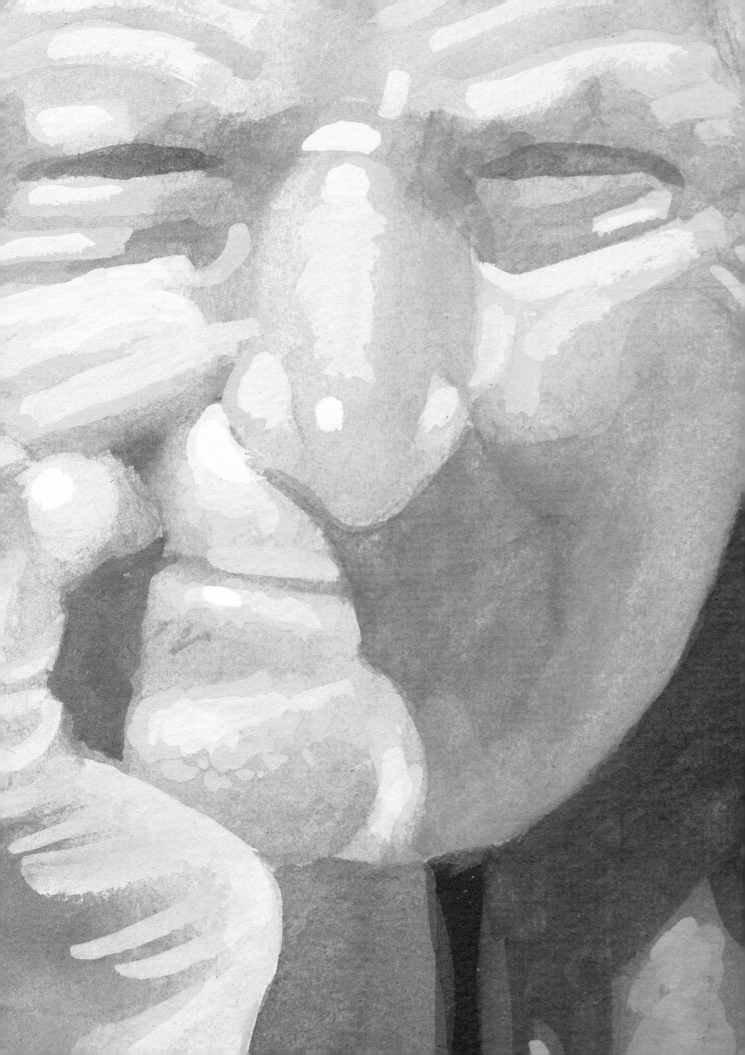

Materials

WATERCOLOUR

Paints

The first decision to make when taking up watercolour painting is whether to go for pure watercolour or gouache. Pure watercolour is available in a variety of different forms, from dry cakes, pans and half pans – which are very small blocks of solid colour – to tubes and bottles of concentrated liquid. Basically it is made from pigment bound with gum arabic. The quality of pure watercolour is reflected in the price: the more you pay, the purer the pigment. It is really only with these pure pigments that you can obtain the brilliance and translucency that makes it such a beautiful medium to work with. Tubes and bottles are very good for laying larger areas of wash, and of course pans are ideal for outdoor work, as they will fit into a box where the open lid can act as your palette.

Gouache is similar to pure watercolour, but contains a proportion of chalk, which gives it an opaque quality. As with pure watercolour, there are numerous colours to choose from, but since it is so simple to mix colours, only a basic selection is required to get you going.

Palettes

Palettes are available in ceramic, enamelled metal and plastic. Those which contain a row of small recesses with a larger row at the front are the ideal answer for mixing pure watercolour from tubes. The paint is squeezed into the small cavity, and then moved into the larger one to be mixed with water as and when required. Although the ready-bought palettes are very useful, it is always possible to improvise with egg-cups and saucers from the kitchen.

Brushes

Without doubt the best watercolour brushes are red sable, made from the tail of the Siberian mink. Although very expensive, if well cared for, they will last a lot longer than the less costly varieties and there will be no problems with moulting hairs. The other types available are made from squirrel – often called camel hair – ox hair, and various synthetic materials. The Chinese hog hair brushes, which are now widely available, are extremely useful as they hold a lot of paint for laying washes but also come to a fine point for painting details.

You will need a good selection of brushes in small, medium and large sizes: flat brushes for laying washes,

round brushes for making expressive strokes, and small brushes for details.

Supports

Watercolour paper is available in a variety of textures, weights and colours. Textures range from rough to semi-rough (cold-pressed) and smooth (hot-pressed), but the most popular choice is semi-rough. The weight (thickness) of watercolour paper ranges from 90lb (180gsm) to 300lb (600gsm). The lighter papers tend to wrinkle when washes are applied and need to be stretched (see page 70). Papers of 140lb (280gsm) or more do not require stretching. Pure watercolour is normally used on white paper, which adds brilliance to the transparent washes, but gouache works equally well on white or tinted papers.

Techniques

WATERCOLOUR

Stretching Paper

Whether you use pure watercolour or gouache, a certain amount of diluted colour will always be used in a painting. Paper absorbs water, which causes it to stretch, and consequentially it shrinks as it dries out. Unfortunately, paper rarely dries flat; instead, it buckles and wrinkles, which ruins your finished painting. The way to overcome this problem is to pre-stretch your paper. You can buy

ready-stretched paper, but you pay a premium. Stretching your own is so quick and easy that the ready-stretched does seem to be an invitation to be extravagant and lazy at the same time!

To start with, collect together the various bits and pieces that you will need *(1)*: a drawing board, a bowl of clean water, a sponge, some gummed paper tape and, of course, a sheet of watercolour paper. Tear off a strip of gummed paper tape for all four sides of the paper, allowing a little extra on each end to be safe.

Lay the paper on the board and fill the sponge with water. Then squeeze the sponge over the middle of the paper *(2)* so that you create a large puddle of water.

Now use the sponge to gently spread the water all over the paper *(3)*. The idea is to get the paper quite damp rather than soaking wet as this could easily damage it. If the paper is fairly thin you should only need to dampen one side of it. However, for the heavier papers you will need to carefully turn them over and then wet the other side in the same way.

Re-dampen the sponge, and run each strip of paper tape along it *(4)* so that it becomes sticky. You can try licking them all, but be warned, you will probably

6

feel very ill afterwards. Whilst you are wetting the gummed paper, your watercolour paper will be absorbing all the water you laid across it and quietly stretching behind your back.

Lay the gummed strips along the side of the paper, overlapping them on to to the board, and then run along each of them with the damp sponge *(5)*, pushing down as you go. Make sure the paper is flat, doing the opposite side first so that you can gently pull out any obvious wrinkles. You do not need to use any force since the drying and contracting of the paper into a set shape will be enough to flatten it.

Allow the paper to dry overnight, and when you return the next day you will have a beautifully flat sheet *(6)* just waiting to be painted on.

PURE WATERCOLOUR

Laying a Flat Wash

One of the most important techniques when working in watercolour is that of laying a flat wash. The first step is to mix your chosen colour with plenty of water in a dish, making sure that you prepare a sufficient amount to completely cover the area that you are painting. Load a large brush with paint and lay it in long, even strokes horizontally across the paper, tilting the board towards you so that the colour pools at the bottom edge of each band and can be picked up with the next stroke. When you have covered the whole area, pick up any excess paint with a dry brush or small piece of tissue, before leaving it to dry. You must still keep the board in a tilted position to avoid the paint from flowing backwards, which will cause the wash to dry unevenly.

Laying a Graded Wash

The technique of laying a graded wash is to start off with a darker tone at one end which gradually fades into a much paler tone at the other. To achieve this you must mix the colour with some water in a dish and keep a jar of clean water next to it. Load your brush with the paint mix and lay a long band of colour horizontally across the top of the paper, tilting the board towards you. Now dip the brush into the clean water and lay the next band underneath, picking up the wet front created by the first band. Continue in this way until the whole area is covered to create a gradation of tone from top to bottom.

Wet into Wet

Wet into wet describes the technique of laying one colour over another before the underlying wash has dried. This can create some interesting results, as the second colour will bleed and merge into the first and enlarge the marks made by the brush.

Wet on Dry

This technique of waiting for the first colour to dry completely before laying another colour over the top will give you a very different effect to wet into wet. Here you can see how the edges of the second colour are clear and well defined.

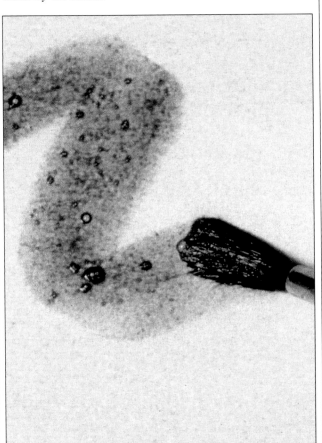

GOUACHE

Wet into Wet

This technique is the same as for pure watercolour – painting one colour on top of another, before the first layer has dried – but because the paint is opaque you can make your second colour lighter. This can create some very exciting results – the marbling effect in this example is one of the most notable.

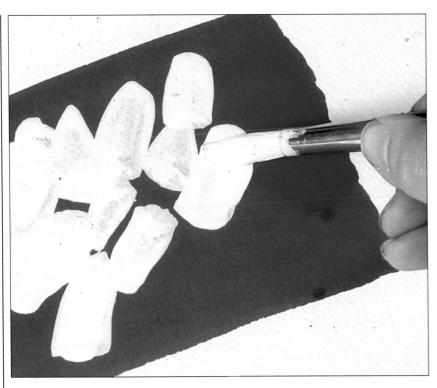

Wet on Dry

Again this is the same technique of painting over another colour that has been left to dry. This example graphically shows the difference between pure watercolour and gouache, in the fact that you can paint white over a dark colour totally successfully. This enables you to work from dark to light, painting in the highlights at the very end rather than having to leave blank pieces of paper as you would with pure watercolour.

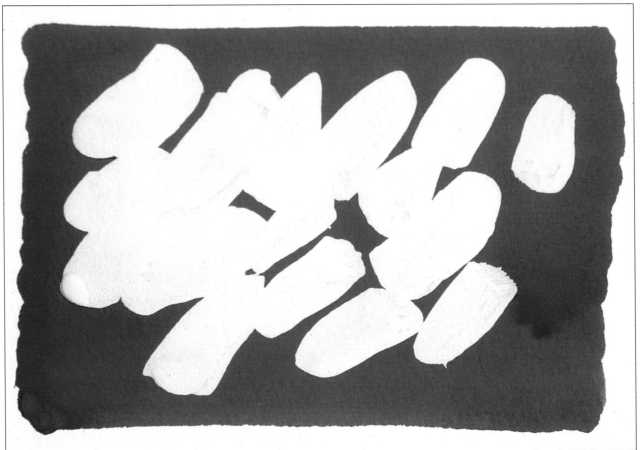

Little Girl

PURE WATERCOLOUR

The reference for this pure watercolour project is a photograph of a little girl. Although she could have posed and been painted from life, children of this age generally find it difficult to stay still for very long. This, therefore, is a good example of when a photographic reference can prove extremely helpful. It allows you to consider the portrait fully before you begin and so decide exactly how you are going to work.

Watercolour allows wonderful spontaneity, but when you are trying to capture a likeness in a portrait it is not a good idea to allow yourself to get too carried away. Skin tones in particular can benefit from the careful, considered approach of working from light to dark, building up depth of tone by overlaying thin translucent washes in overlapping areas. All the flesh tones in this painting are produced in this way from just a few colours.

Do not become disheartened if your painting does not end up looking like the one here – the artist in this case has been working with watercolour for many years. Practice is, in essence, the secret to pure watercolour. By working with the medium you will gradually build your confidence as you begin to understand how the paint will behave in a given circumstance. When you know what it is capable of you can then put this knowledge to good use.

1 On a sheet of 15x22in. (38x56cm) pre-stretched (see page 70) watercolour paper (200lb/430gsm Bockingford), map out the outlines and main colour areas with a HB graphite pencil. Keep the pencil marks as faint as possible as watercolour is a translucent paint and it will not be able to hide these marks to any great degree.

2 Start by laying a dilute wash of Naples yellow, with a small amount of cadmium yellow added, on to the hair area with a no.8 round, soft hair brush. While this dries, mix up a very weak wash of cadmium orange and brown madder alizarin and subtly suggest the first base skin tone.

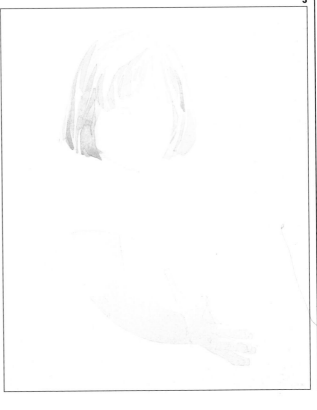

3 Mix together Naples yellow with some yellow ochre to create a variation on the hair colour – still a thin wash – and, with a no.4 soft hair brush, begin to suggest the darker areas in the hair over the top of the first, now dry, wash. Darken your skin mixture of cadmium orange and brown madder alizarin by adding slightly more pigment and overpaint the darker areas on the face and arms. Allow the painting to dry fully between each application of paint. It is best to let this happen naturally, but if you are in a hurry you can speed the drying process by using a hairdryer on a very gentle setting. However, take care not to hold it too close or you might push the wet paint around the picture.

9 Darken your shadowy skin mix (brown madder alizarin, cadmium orange and cobalt blue) by adding some Payne's grey to it, and use it to establish the dark area on the mouth. You can also use the Payne's grey mixed with cobalt blue to repaint the eyes and give them a bit more sparkle.

Use turquoise with a little sap green to suggest the pattern on the dress.

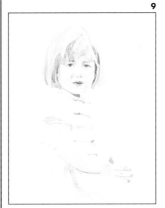

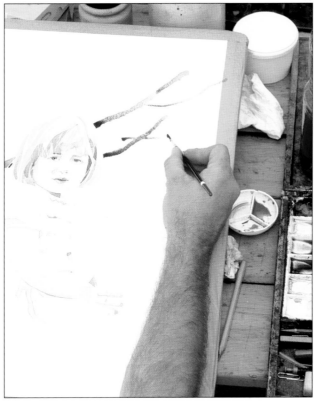

10 You need to continue the gradual process of building up tone by overpainting until you feel you have reached the desired result.

Return to the dress with the cobalt blue, sap green and Payne's grey mix – but this time more dilute – and continue the build-up of form and tone by establishing the contrast between highlights, mid-tones and shadows.

When you are happy with the dress, re-establish the lips – to add more interest to the face – with cadmium red and a little brown madder alizarin.

11 To help make the figure seem more three-dimensional, it needs to be 'pushed' out of the painting with the aid of some form in the background. Create two mixes of sepia with Payne's grey. To one mix add more sepia so that it turns brown. Use this to suggest branches sweeping across the background.

12 Mix a lot of sap green into both your sepia and Payne's grey mixes so that they turn into two distinct shades of brown-green. Then roughly block in the background, alternating between both mixes, and switching back to your no.8 soft hair brush once you have moved away from the outline of the girl.

You can then return to the girl's face to add any finishing touches you may feel necessary. But take care not to overwork your painting as it is all too easy with pure watercolour to put down too much paint and spoil its wonderful translucency – undoubtedly one of watercolour's best features.

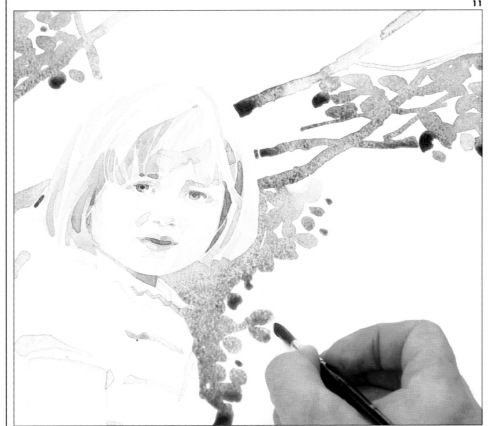

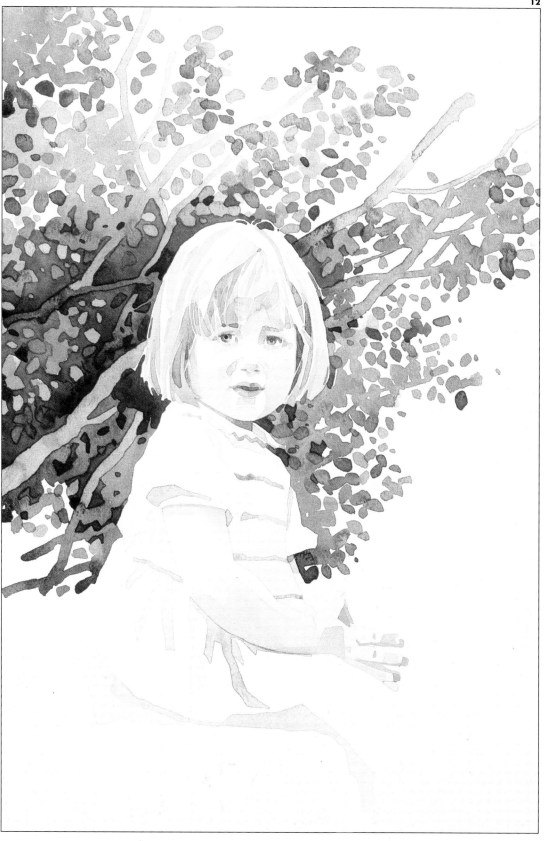

Italian Grandmother

GOUACHE

This project was chosen especially to present you with a challenge. Although you will be working from a specific piece of reference, we are going to give you plenty of opportunity to use your imagination. This is because you will be translating a black and white photograph into colour. As this is a picture of a typical Mediterranean grandam, there will be certain elements which are obvious, such as her skin is sure to be tanned and her clothes black.

Our artist chose to paint the window frame green – as this is fairly common in the Mediterranean – and therefore the shawl is painted in a muted red to compliment the green. The rest of the colours were chosen to suggest bright sunlight but ultimately the choice is yours. In this painting we used a limited palette of paints to encourage you to be creative with your mixing and not to be too literal with colours.

84.

85.

1 Before starting your painting you will need to prepare your support. Using a sheet of 200lb (430gsm) Bockingford water colour paper, stretch it (see page 70) and leave it to dry overnight. This done, it is also a good idea to keep the paper attached to the board as this will prevent it from buckling when you lay the initial washes. Now mark out the main outlines with a soft 3B pencil. These will be lost under the paint as the picture progresses.

2 The first stage is to block in the different areas of the painting with a general thin layer of underpainting. The first wash is made up of red ochre, burnt umber and indigo, which will create an interesting neutral background to the painting. Using a no.6 sable brush, pull in the individual colours at random to vary the shade as you progress. When you have laid this first all-over wash, paint in the headscarf with a little indigo and burnt umber and indicate the window frame with indigo and yellow.

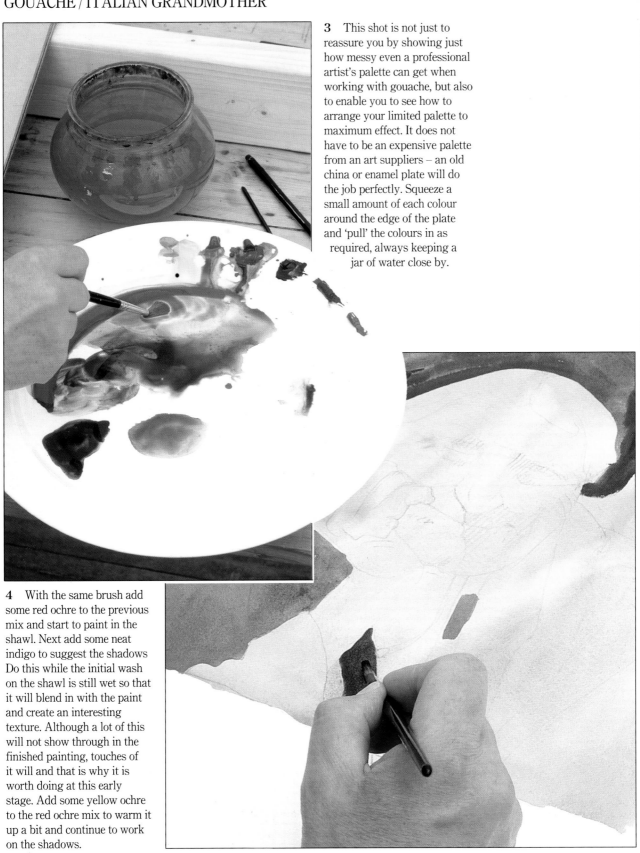

3 This shot is not just to reassure you by showing just how messy even a professional artist's palette can get when working with gouache, but also to enable you to see how to arrange your limited palette to maximum effect. It does not have to be an expensive palette from an art suppliers – an old china or enamel plate will do the job perfectly. Squeeze a small amount of each colour around the edge of the plate and 'pull' the colours in as required, always keeping a jar of water close by.

4 With the same brush add some red ochre to the previous mix and start to paint in the shawl. Next add some neat indigo to suggest the shadows Do this while the initial wash on the shawl is still wet so that it will blend in with the paint and create an interesting texture. Although a lot of this will not show through in the finished painting, touches of it will and that is why it is worth doing at this early stage. Add some yellow ochre to the red ochre mix to warm it up a bit and continue to work on the shadows.

5 With a mix of burnt umber and indigo block in the curtain. This mix will be the same for all the underpainting of the white areas such as the net curtain and the lady's sleeve.

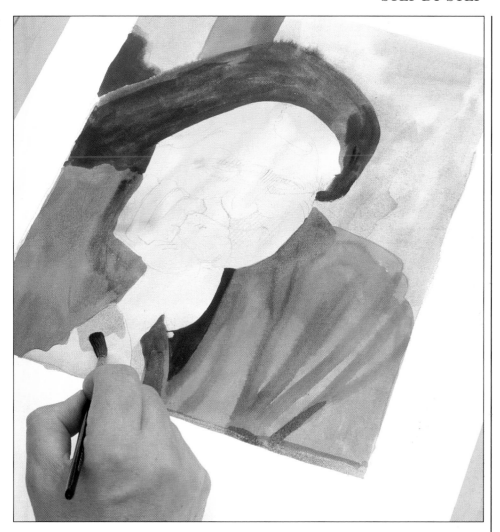

6 By now you will have completed a lot of the underpainting, so it is time to start working up the painting. With the same no.6 brush and a mix of yellow ochre and red ochre, start to add the light and dark areas of the face. For the darkest shadows drop in a tiny amount of indigo. Paint all these areas wet into wet so that the colours merge with the soft edges. With a new wash of burnt umber and indigo, paint over the hair. Return to the 'face' mix of yellow ochre and red ochre, and use it to lay another wash over the shawl.

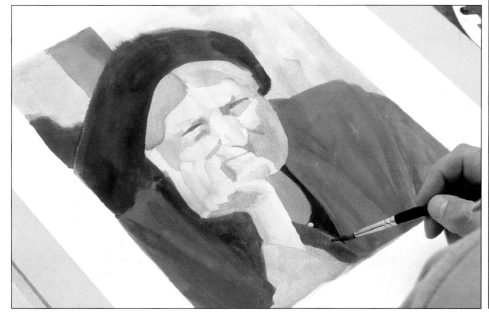

7 While you are waiting for the previous washes to dry, mix some permanent white with a dash of yellow ochre and paint in the background wall. If the face is dry, mix some yellow ochre and red ochre and loosely add the wrinkles. You will still be using the no.6 brush, even for detailed work, as sable is so soft that it can be rolled to a fine point.

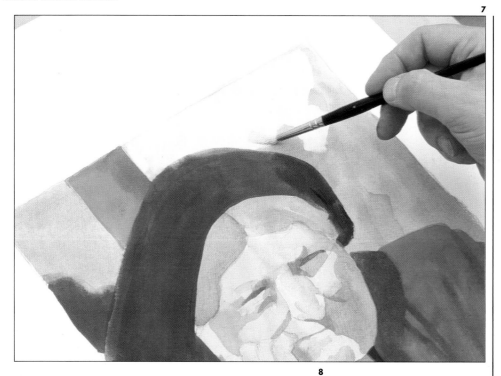

8 Continue with the same mix but with a little indigo added and paint in all the darkest areas of flesh, such as the shadows under the chin and down the side of her hand and arm. Mix some burnt umber and indigo to heighten the shadows on the shawl. Return to the face and, with the revised flesh mix of yellow ochre, red ochre and a touch of indigo, deepen the shadows under the nose.

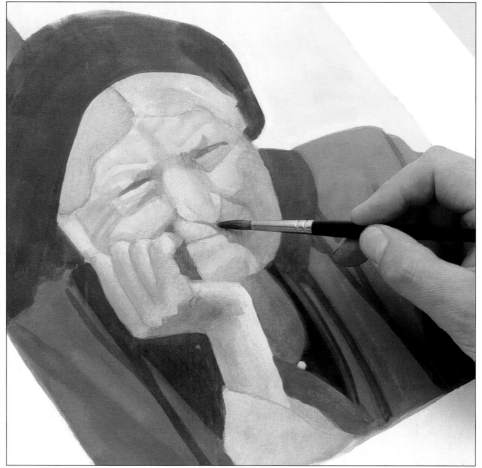

9 When the previous wash has dried, paint over the whole of the face with a fresh mix of yellow ochre and red ochre. Do this with broken strokes so that the paint dries unevenly, which will add texture as well as extra interest.

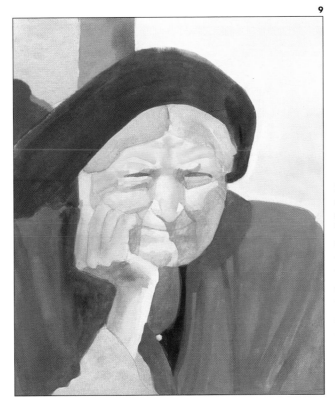

10 With a fresh wash of permanent white and a tiny drop of yellow ochre, paint over the wall at the back. When you have done this, dab it gently with a tissue to blend the colours and add texture. With a permanent white wash (no added colour) paint over the curtain and the white of the sleeve, building up the opacity (using less water) as you go. Add some indigo and burnt umber to the white for the darker shadows which fall in the white areas.

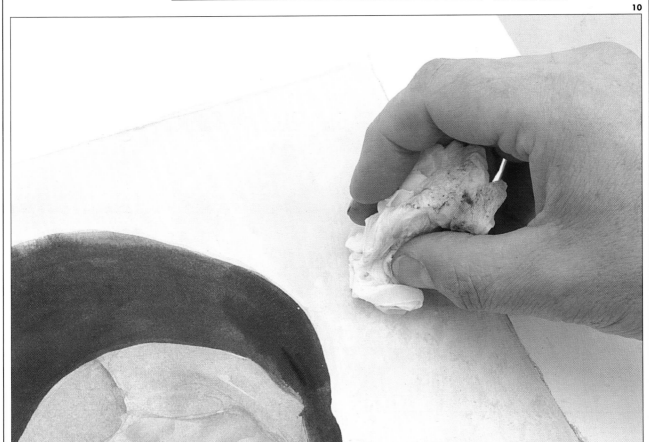

11 Using a fresh permanent white wash paint over the sleeve. To avoid smudging, wait for the paint to dry. Then add some more white paint to your mix to thicken it up and add the highlights that run through the hair and dot the tiny button of the blouse again. Although this accentuates it more than in the reference picture, it serves a purpose by breaking up that area of dark shadow.

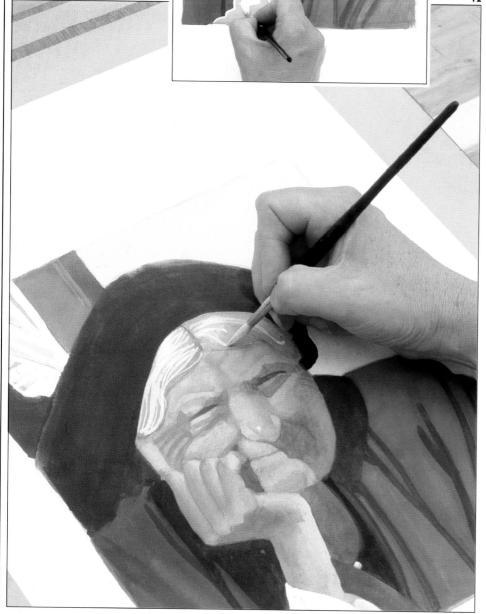

12 With a thick mix – very little water – of yellow ochre and red ochre scumble the paint with a dry brush over the shawl, which will re-create the texture and weave of the fabric. Using a fresh permanent white wash indicate the texture of the hair with small fine brushstrokes.

13 All there is left to do now are the finishing touches. With an opaque mix of yellow ochre, red ochre and white, pick out the highlights on the face. Lighten the mix with a little more white and go over the brightest of the highlights, then repeat this process for the hands and all the skin tones.

Finally, stand back and take the time to view your work. You will now be able to see just how effective working with a limited palette can be. Not only does it encourage you to be more creative and get the most out of the colours, but it also enables you to focus more on the painting as opposed to becoming distracted by decisions as to which colour to use. Also, on the practical side, with the money you save on not having to buy all those extra colours, you can afford to invest in that sable brush!

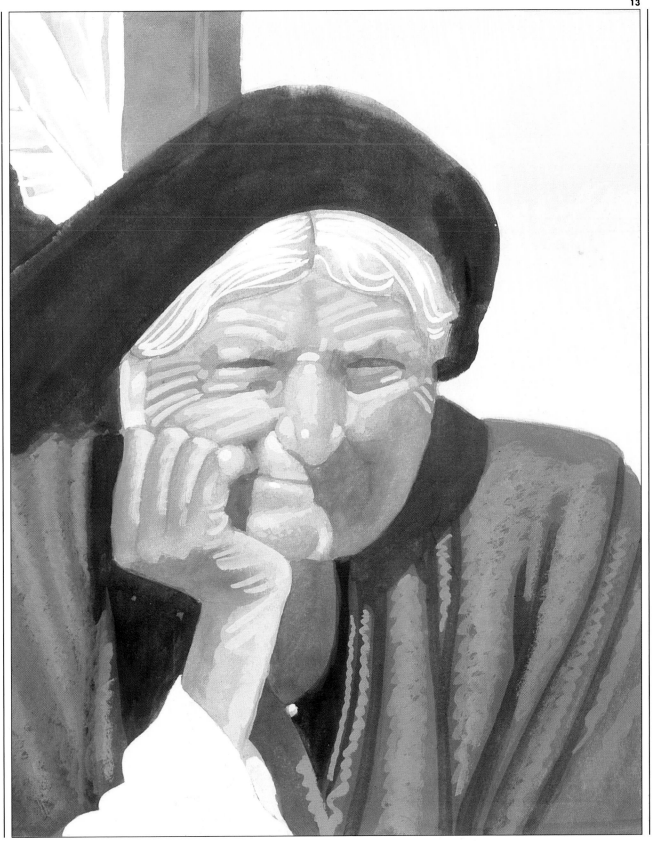

Chapter 6
Acrylics

In this chapter we explore a fairly new and modern medium, acrylics. Synthetically made acrylic paints were developed in the 1920s and were intended for industrial use. However, owing to their weather resistance and fast-drying qualities, artists working in Mexico began to use them to paint huge murals. With the advent of a radical new style of painting in the 1950s and '60s, acrylics came into their own. This new movement, known as 'Pop Art', called for bold, bright colours to suit its brash personality. The 'Pop' artist depicted the modern environment by using images from American popular culture – everything from soup cans to hamburgers. It was an experimental period, and discovering the creative potential of a truly modern paint medium added to the excitement. When the likes of Warhol, Hockney and Lichtenstein gave it their seal of approval, acrylics were finally accepted.

Since this time artists have discovered that acrylics can be far more subtle than originally thought. In this chapter we present you with two paintings designed to demonstrate just how versatile acrylics can be. On the one hand we give you a bright and bold piece which you approach in a fairly loose and uncontrolled manner. For the other project we adopt the opposite approach – a carefully considered piece which is built up slowly and has great subtlety. Whichever approach you prefer, both will be great fun to tackle.

Materials

ACRYLICS

Paints

Acrylic paints consist of pigments bound in a synthetic resin and suspended in water. Acrylics can be diluted with water, but once they have dried on the support they are water resistant and are probably one of the most hard wearing and permanent of all media.

The choice of colours is vast, with all the traditional hues being readily available, but since they mix so well, a palette of about twelve basic colours is normally more than enough. Like oils, acrylic paints are available in both artists' and students' quality. Less costly PVA and vinyl paints are also sold, especially for use on large areas, but the pigments are of a poorer quality. Artists' quality acrylics will never discolour with age, mix together extremely well, and are so flexible that a painted canvas could be rolled up and the paint would not crack. It is for this reason that some people even use them to paint designs on leather jackets. This versatility is half the fun of using acrylics.

Mediums

There are various acrylic mediums which can be added to the paint to produce different effects. The two main types of medium are those that turn the finish more shiny or matt. They both make the paint more transparent and fluid, so are useful when glazing with thin, smooth layers. In addition to these, mediums are available for nearly any effect you can think of. These include ones which increase acrylic's adhesive properties, gels for thickening the paint, right through to retarders, which slow the drying time down by several hours.

Supports

Acrylic paint can be used on almost any surface. The only ones to avoid are those which contain wax or oil, since the paint will not adhere to such a surface and may peel off once it has dried. For this reason, canvases or boards specifically prepared for oil paints should be avoided.

Canvases primed specially for acrylic paints are available, but a less costly alternative is hardboard. Depending on your preference, you can choose to paint on either the smooth or the rough side. The surface can be sealed with acrylic medium or, if you prefer a white support, with acrylic gesso.

Brushes

Your choice of brushes will largely depend on the style and techniques that you use. If you tend to use a

watercolour approach, then use watercolour brushes; for an oil approach, use oil-painting brushes. Because acrylic paint dries so fast your brushes can be easily destroyed. Be sure to moisten your brushes with water before loading them with acrylic paint, to prevent a gradual build-up that could ruin them. During a painting session, keep your brushes in a jar of water when not in use so that the paint cannot dry on them – and wash them thoroughly at the end of the session. Most artists find synthetic brushes made of nylon better for acrylics as they are easier to clean and are inexpensive enough to replace frequently.

Palettes

Palettes for acrylic painting are made of white plastic, which is easy to clean. Wooden palettes are not recommended as the paint gets into the grain of the wood and is impossible to remove. A special 'Staywet' palette has been developed which keeps the paints wet for days.

Techniques

ACRYLICS

Glazing

When you add acrylic medium to acrylic paint, it turns transparent and dries to a gloss or semi-gloss finish. This gives you an opportunity to try a kind of optical mixing called glazing. A glaze is a thin layer of transparent colour which is applied over an opaque, dry layer of paint; the glaze combines with the colour below to create a third colour – for example, blue glazed over yellow produces a greenish tint – but the effect is quite different from an equivalent physical mixture of the two colours. This is because the glaze, being transparent, allows light to reflect back off the underlying colour, creating a luminous effect.

Glazing is traditionally associated with oil painting, but acrylics are ideally suited to the technique; unlike oils, they dry in minutes, and are insoluble when dry, allowing you to build up several glazes in a short space of time and with no risk of disturbing the underlayers.

To create a sample glaze *(1)*, brush on a few broad bands of colour diluted with just a little water. When this is dry, dilute a second colour to a transparent consistency with acrylic medium and paint a few bands across the base colour, leaving some of it exposed. When the glaze dries, you will see three areas of colour: the two original colours and an optical mixture where they overlap.

Glazing can be used to enhance layers of thick, heavily textured paint known as impasto *(2)*. The thinned colour settles into the crevices in the paint, accentuating the texture – a useful technique for painting the bark of a tree or a weathered stone wall. Cover a small area with thick paint, allowing the brushstroke texture to remain. When dry, glaze over it with colour thinned with acrylic medium, forcing it into the crevices to expose the peaks.

1

2

Scumbling

Another way of mixing colours optically is by scumbling. Here opaque or semi-opaque paint is laid unevenly over a dry layer of paint so that only parts of the under-colour are still visible. Lay down a small area of paint, applying it very thickly so that you get a rough, uneven surface. Allow this to dry completely, and then use another colour to lay some random brush marks over the top. The top layer picks up the contours of the paint below, yet still allows it to show through. Scumbling can also be used in a much more subtle way, with the top layer being put on more as a hazy mist to create the effect of a foggy mix of colours.

95

ACRYLICS

Wet into Wet

Diluted with plenty of water, acrylics can be used in the same way as watercolour paints yet still retain all the unique properties of the newer medium. To paint wet into wet, brush a coloured wash, well diluted with water, on to the paper. Immediately apply a wash of your second colour next to the first and allow the two colours to meet, blending them slightly with the end of your brush. You will find that adding a little matt or gloss medium to the paint will give you greater control over the washes.

Blending

Because acrylics dry so much faster than oils, subtle graduations and blendings of colour are more difficult to achieve. However, the addition of a little gel medium to the paint gives it a consistency nearer to oil paint and prolongs the drying time.

Another alternative, shown here, is to rough-blend using short, dense strokes. Working quickly, before the paint dries, apply the two colours next to each other and 'knit' them together by stroking and dabbing with your brush at the point where they meet.

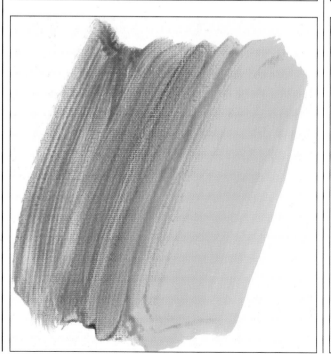

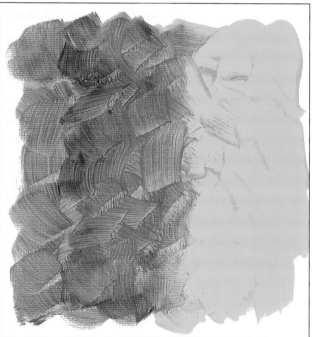

Sgraffito

To create interesting textures and highlights any sharp tool can be used to scratch lines into acrylic paint while it is still wet. Experiment with different tools – palette and painting knives, the end of a brush handle, even your fingernail – to discover the variety of textures and patterns that can be achieved. You can also scratch through a layer of paint to reveal the underlying colour – as the artist has done here.

Lay a base coat, then, when it has dried, paint over it in another colour *(1)*. We used two tones of the second colour, but one tone is sufficient. While the paint is still wet, scratch tiny marks all over it with a palette knife *(2)*. Keep the pressure light as you do not want to scratch through the first layer of paint or damage the surface of your support. You can see how the initial layer of paint shows through, creating an interesting, two-toned textural effect.

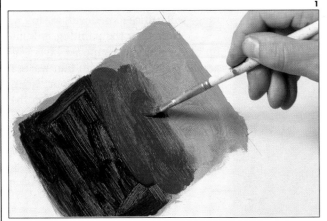

1

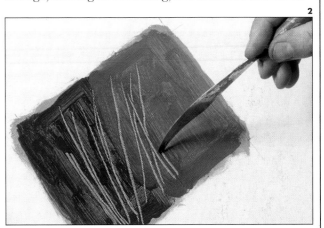

2

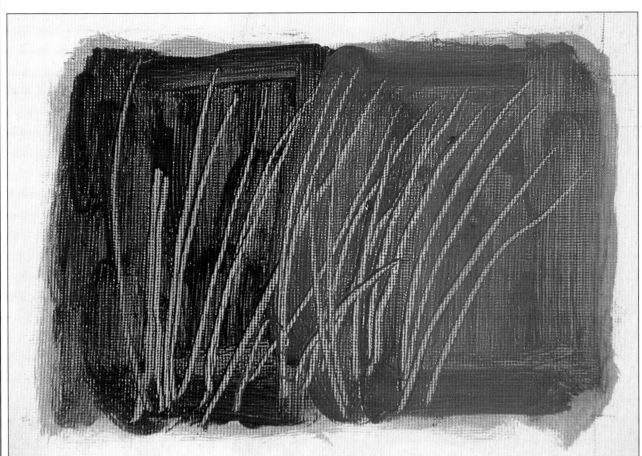

3

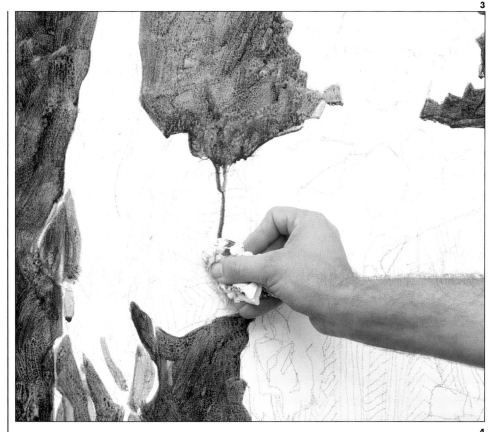

3 Allow this initial layer of paint to dry. This will not take long as it was such a watery mix. When it has dried, apply a second coat of sap green and Payne's grey with the flat brush, but this time with more sap green in the mix. By applying two thin coats in this way you get a depth of tone through the play of light and dark areas.

If you put too much paint on the canvas, it will tend to collect at the bottom of the painted area and can even trickle down over the rest of the painting. You can simply remove this excess paint with a clean, dry brush or a small wad of tissue.

4

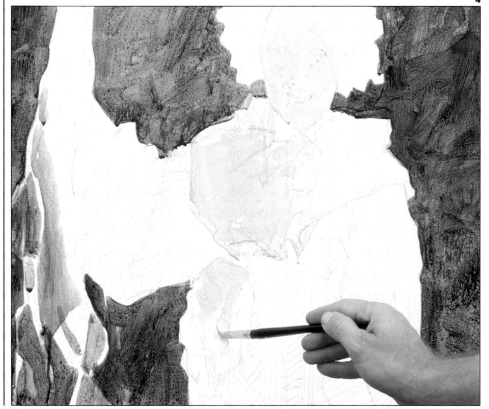

4 Dilute some Naples yellow and add a small touch of ivory black into it. Then block in the whole of the face – including the teeth – with a ¹/₂in. (13mm) round brush. Details, such as the eyes and mouth, will be worked up later.

Next, use dilute permanent light blue to block in the ruffle around the clown's neck. Add white to the blue for the lighter section on the right.

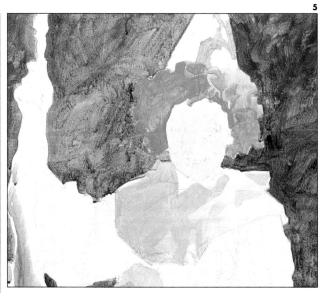

5

5 Moving on to the hat, mix a small amount of white into cobalt blue and block in the blue section of the hat. Suggest the hair with turquoise green.

By now the ruffle should be dry, so return and overpaint its darker sections with a more saturated mix of permanent light blue. In much the same way overpaint some of the hair with the turquoise green darkened with cobalt blue.

Then allow your painting to dry and clean your palette, scraping off the worst with a knife and then running it under the tap. Now you can add some brighter colours.

6 Return to the painting and block in a few of the balloons, some with cadmium orange, some with alizarin crimson and others with scarlet red. These hues can be mixed together to produce further variations for the balloons and to paint the red spots on the clown's hat.

6

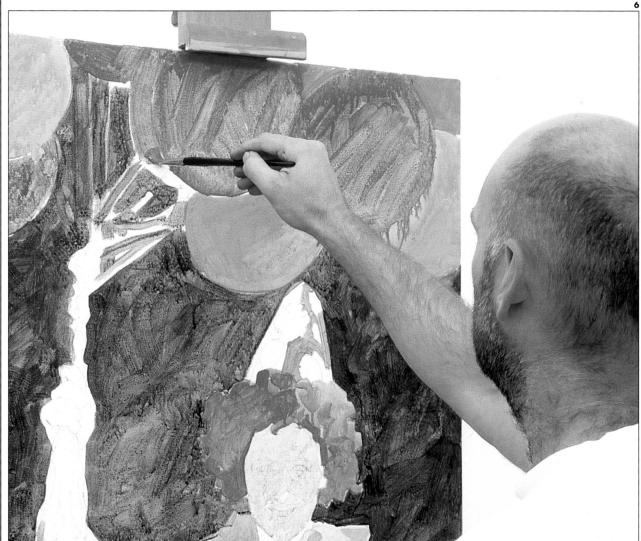

7 Now mix together cadmium orange, alizarin crimson and a little sap green to get a base colour for the clown's clothing. Although the clothing is patterned, the colour is predominately of an orange/brown tone and this is why you lay this base tone down first. With acrylics it is easy to superimpose light or dark colours over the initial base tone.

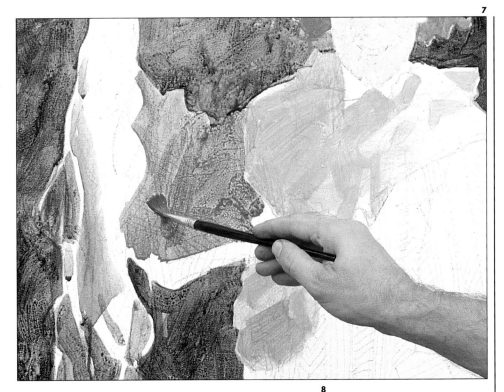

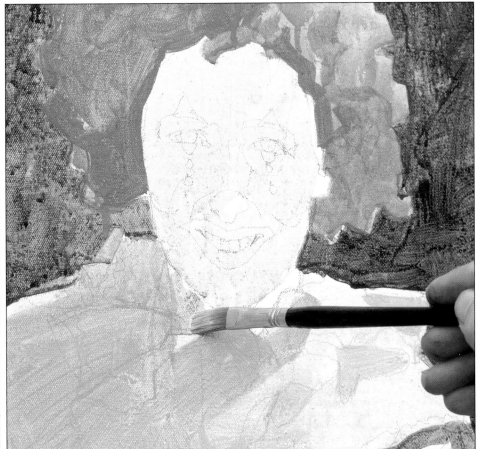

8 By blending some white into the clothing mix you will get a flesh tone which you can use to paint the arm, hand and small portion of neck just visible above the ruffle. Use this mix also to paint over the lightest parts of the shirt.

Sap green mixed with yellow medium azo gives a good strong green for adding another spot on the hat and to suggest the ribbons hanging from the balloons. Paint the left side of the hat, excluding the large spots, with yellow medium azo.

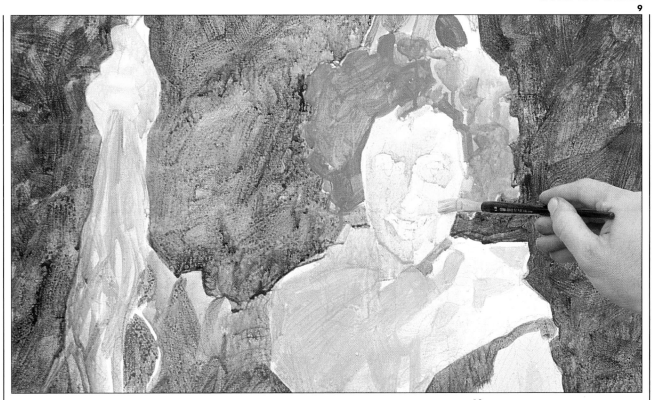

9 If you mix a little Payne's grey into your skin mixture (cadmium orange, alizarin crimson, sap green and white), you will get a weak coloured grey for painting the shadowy areas on the face.

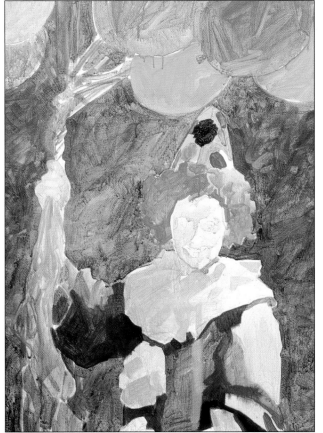

10 Use Mars black to block in the rosette on the hat, then mix cadmium orange and alizarin crimson into it for the dark areas on the shirt. Now, the whole canvas is covered and you can concentrate on developing the light and dark areas, that is 'modelling' the forms in the painting.

Work up the brighter areas of the clown's suit using an ever-changing mix of cadmium red, cadmium orange and the pink you mixed earlier for the skin tones.

11 Next, switch to a ¹/₄in. (6mm) flat brush and work on the details of the face. Use the brown shirt mix for the eyes and cadmium red deep for the lips.

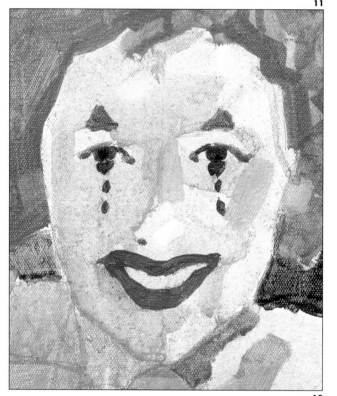

11

12

12 While the face dries, paint over the general areas of the balloon strings with magenta. You will return to the strings later to sharpen them up.

Back to the face, add a touch of alizarin crimson to some white to create a very pale pink with which you can paint the highlights. Do not add so much water to the mix this time; the paint needs to be thicker and more opaque. Work away from the highlights by varying the tone with small amounts of cadmium orange, yellow ochre or cobalt blue. The colours on the face are very peculiar because of the clown's make-up and the reflected colour from the green hair.

By darkening a mixture of cadmium red and yellow ochre with a little Mars black you will get a dark skin tone which you can use for the deepest shadows on the face, neck and hand.

13 You can now paint the darker areas in the hair using turquoise green with a little sap green and cobalt blue added.

Give the hair a chance to dry by switching your attention to the background. Change to a ¹/₂in. (13mm) flat brush and use a mix of sap green with some yellow medium azo and titanium white to repaint the bottom of the background and to add broken strokes higher up to suggest foliage.

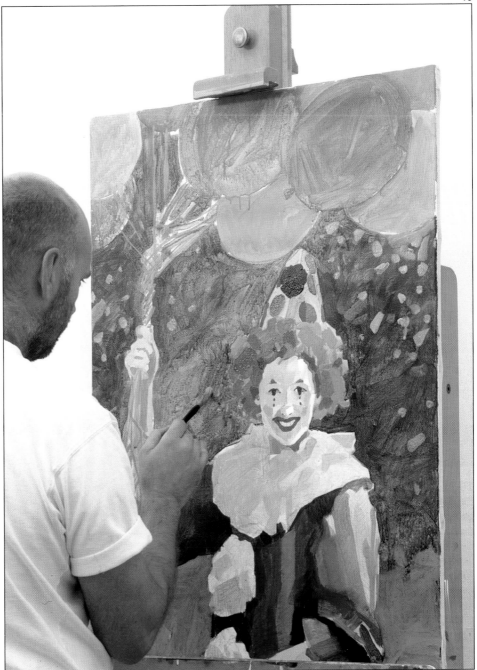

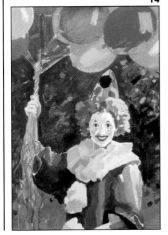

14 Now return to the blues of the ruffles. Use a mix of cobalt, cerulean and permanent light blues, changing the balance between them to emphasize the light and dark areas.

By now the hair should have dried – test it with the tip of your finger to make sure. Now you can add the high-lights with turquoise green lightened with titanium white.

Repaint the blue half of the hat with cerulean blue, lightening it with titanium white for the highlights and darkening it with sap green for the shadows. Then create a dark green from sap green, cadmium red and a little ivory black to overpaint the green background in the darker areas.

While this dries you can model the balloons by repainting them in tones of red and orange. As you finish each balloon, add titanium white to the mix and dab in some highlight streaks.

Kavango Woman

ACRYLICS

So far we have tended to concentrate on head and shoulder poses, but portraiture can frequently include the whole or part of the figure. People often think of portraits as being rather formal so we decided to break with tradition on both counts and present you with a figure in a natural pose. We used a photographic reference for this project, but you will find travel books and magazines are also very good sources of inspiration, especially for more exotic subjects.

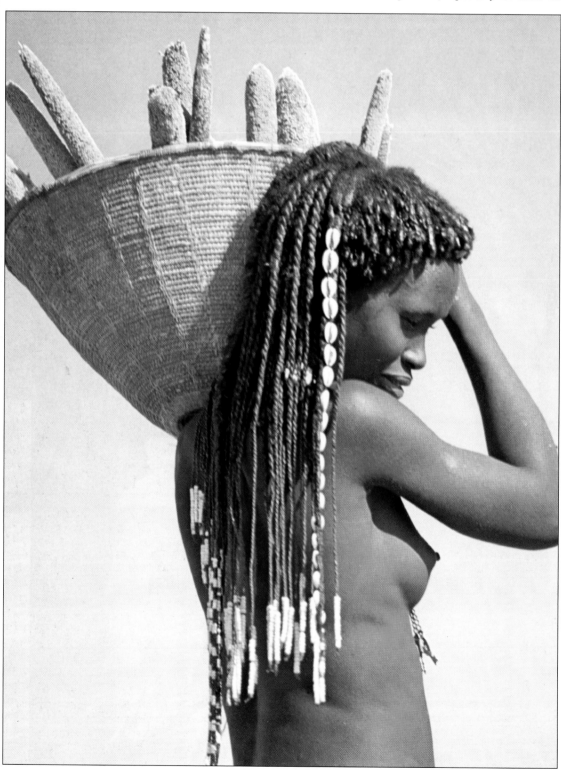

1 Take a piece of cotton duck canvas 14x18in. (35.5x45cm) and prime it with acrylic gesso. Or alternatively you can be lazy and buy a piece ready primed. Make a detailed sketch with a 3B pencil, mapping out the dark and light areas. Notice the marks on the canvas where the artist has changed his mind, erasing certain elements or correcting them. It is a good idea to have a clear view of the tonal distribution in the composition now and none of these marks will show through in the finished painting. When your drawing is complete, do not forget to spray it with fixative before you start to paint so that the graphite does not muddy the first layers of paint.

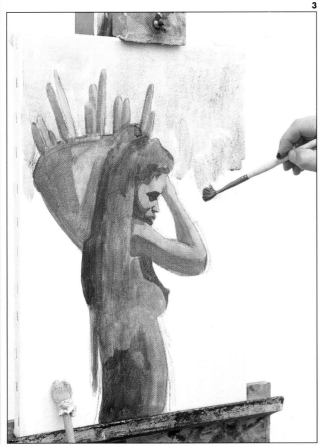

2 With a no.6 filbert (a flat brush with a rounded tip) and a mix of yellow ochre, cadmium red medium, black and lots of water, wash over the whole painting. This initial wash will form the base upon which you can work and give the painting an overall sense of harmony. To create the different tones in the early stages of the painting just alter the ratio of colours. For example, add more yellow ochre to the wash for the lighter areas of the basket and maize. The tonal strength of these colours can also be varied by adding more (lighter) or less (darker) water.

3 Continue to cover the whole of the figure, altering the ratio of the mix as you go but still sticking to the initial colours. Use a mahlstick to keep your hand steady when painting the smaller, darker shadows. Paint in the sky with a new wash (lots of water) of ultramarine with a drop of cadmium red medium, which makes the blue less stark as well as keeping it in harmony with the rest of the picture.

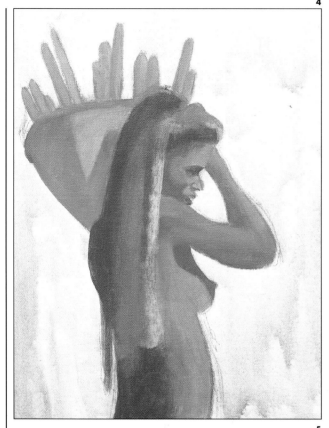

4 Mix together cadmium red, cadmium orange with a tiny bit of black to add depth. With the same brush, start to build up the darkest shaded areas of the basket. Add some more cadmium red and black to really darken the mix and start to go over the hair and the dark shadows of the back. Now add some yellow ochre to the mix and go over the rest of the hair. Add yet more yellow ochre and some cadmium orange and paint over the torso and the upper arm which is in the light.

5 With the same brush, paint over the top of the sky with a mix of ultramarine and white. Switch to a no.6 round soft-hair brush and cut in around the basket, maize and the top of the head. With a change of brush again, this time to a no.6 filbert, add a lot of white and a touch of Phthalocyanine blue – as it is a strong colour – and fill in the rest of the gradually warming sky towards the bottom. Leave the cutting in around the silhouette of the body until later, as you will need to switch to the finer no.6 soft-hair brush for this more complex outline.

6 Using a fresh, thick (little water) mix of yellow ochre, cadmium orange and white, switch to a no.4 flat bristle brush and paint over the cobs of maize. Add a little cadmium yellow medium to brighten the mix and continue to paint the lightest shades of the maize. To the same mix add some yellow ochre and cadmium red and paint the top rim of the basket. Sticking to the same brush, but with a new mix of cadmium orange, yellow ochre and white, paint in the lighter reflections of the maize. For the sunlight on the maize use a mix of white, cadmium yellow and a touch of yellow ochre. Add some cadmium red and yellow ochre to this mix and start to add the highlights on the skin.

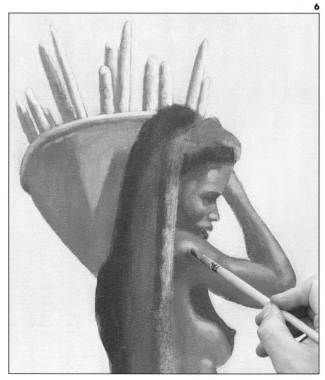

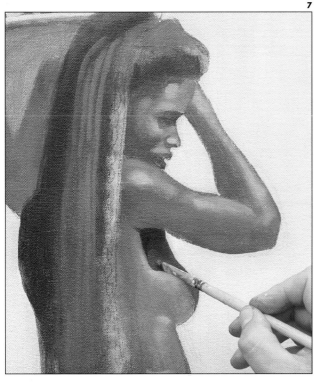

7 Take some cadmium red, cadmium orange and black and start to work on the plaited strands of the hair. With another mix of cadmium red, black and a touch of yellow ochre, switch to a no.4 flat brush, work up the darkest shadows of the skin using a mahlstick to steady your hand.

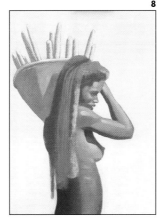

8 Start to model and work up the rest of the body using a single, basic mix of cadmium red, yellow ochre and black, with an occasional drop of cadmium orange. Keep varying this basic mix as you go. It is impossible to give you exact ratios so keep referring back to the reference and use your eye.

9 Continue to work with the same mix but with the bias on yellow ochre and white when adding the highlights to the face. Switch to a no.6 soft-hair brush and a new mix of yellow ochre, cadmium red, black and white. Start to define the facial details such as the shadow under the nose, the upper lip and the shadow underneath the eye. Then add a lot more white to this mix and continue to add the areas of highlight, which will have the effect of bringing the face into focus. With a fresh mix of cadmium red, black and white redefine the outline of the lips. Add a lot of black to the mix and paint in the eyebrow and the eye. When working on small details it is always a good idea to use a mahlstick to avoid any accidental smudges.

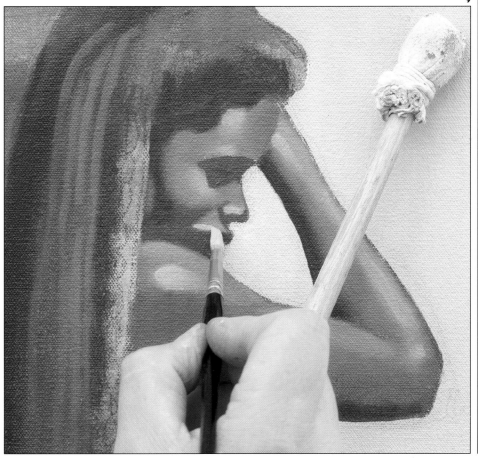

10 Using the same mix, move on to the hair and start to paint in the outlines of the shells and the dark shadows which run down the side of the braids and the string around her hips. Add more cadmium red and a touch of cadmium orange and paint in the areas of flesh showing through the braids.

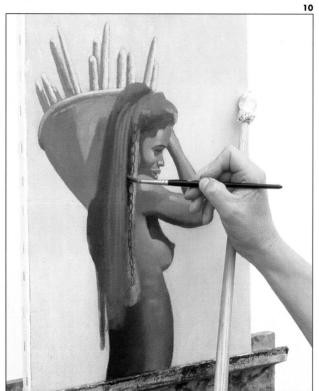

11 With a fresh mix of cadmium red, black and a touch of white, lay the 'foundation' colour of the hair. Now mix some yellow ochre, cadmium orange, cadmium red and black, and indicate the form of the basket. Add some more cadmium orange and yellow ochre with a touch of white and paint over the main area of contrasting tone on the basket.

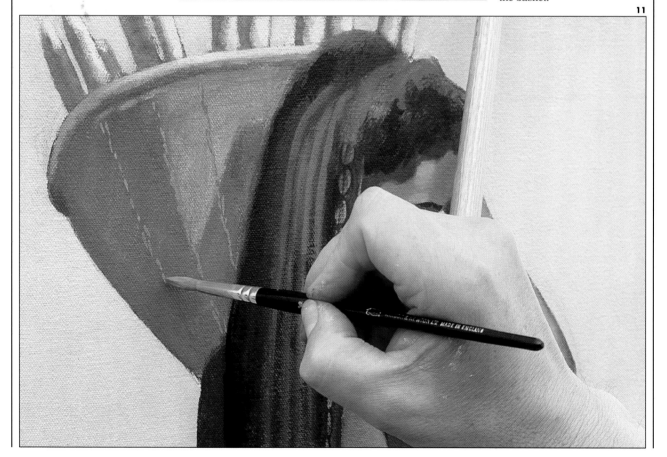

12 Sticking to the same mix and brush, start to indicate the actual weave of the basket. With a lighter mix of cadmium orange, yellow ochre, cadmium yellow and white define the areas of the weave which catch the sunlight.

13

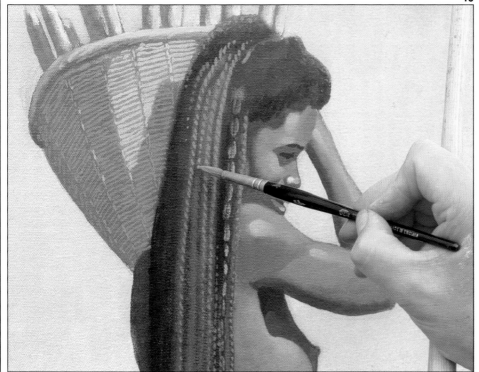

13 Without changing the brush but with a fresh mix of cadmium orange, cadmium red, black, white and little yellow ochre, start to overlay the pattern of the braided hair. This is done with short strokes as if you were making a tick. Add more white and go over the ticks again. For the shells use a mix of black and white and then paint over them again in white. Return to the black and white mix and paint in the white beads at the bottom of the braids.

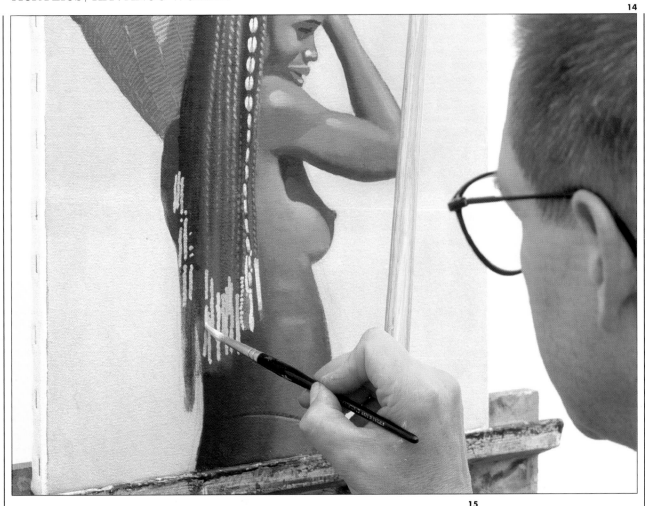

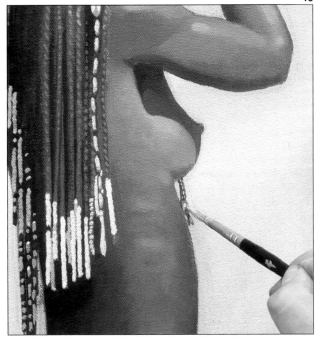

14 Now fill in any gaps where the flesh shows through with a mix of cadmium orange, cadmium red and black. Mix some cadmium red and black to add the red beads on the braids and go over the white beads in black and white.

15 Paint over the beads again in white, but instead of dotting them individually, use a squiggle motion. With black, yellow ochre and a touch of white, paint in the chain and the ornament around her neck. Add more yellow ochre to the mix to create the middle tone, then finally finish the ornament and chain off with yellow ochre and white to add the bright reflection which makes them appear to shine.

16 At last you can step back and admire your work. Don't worry if your painting does not look exactly like ours; what is important is to use the projects as a guide to help build your confidence and encourage you to do your own thing. This project is particularly good for the way it shows how to recreate bright sunlight and how this in turn effects the colours of all the individual elements in this portrait, from the weave of the basket to the varying tones and shadows of the skin.

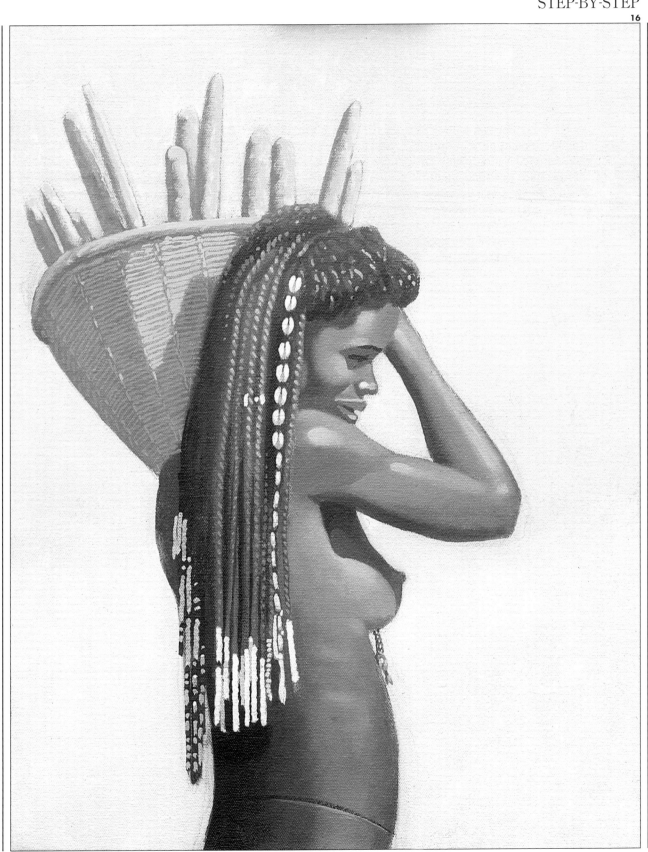

Materials

OILS

Paints

Oil paints come ready prepared in tubes and are made up of pigments suspended in an oil binder such as linseed or safflower oil and occasionally poppy oil, which is quicker-drying. There are two grades of oil paint available: artists' and students'. Both are available in a wide range of colours. Although the artists' grade contains more pure pigment and is therefore more expensive, the students' grade is perfectly adequate and is fine for practising with. The only problem is that not all the colours are obtainable in the students' range, but the two types will mix quite happily in a single painting.

Painting Mediums

Although oil paint can be used directly from the tube, more often a medium is added which alters the consistency of the paint and makes it more malleable. There is a variety of mediums available and they all affect the drying rate, flow and texture of the paint in different ways. The most common is a blend of 60% linseed oil and 40% turpentine or mineral spirits, but be sure to buy purified or cold-pressed linseed oil, which does not yellow with age. Other mediums include beeswax, which dries slowly and gives a matt finish, and gels (synthetic resins), which provide extra body.

Supports

Oil paint can be applied to practically any surface, from canvas – the most commonly used – to wood and hardboard. Stretched canvas provides the perfect support but it is expensive and there are less costly alternatives. Ready-primed canvas boards are convenient to use, and oil-sketching paper, available in pads, is handy for outdoor work. Hardboard, and even cardboard, are inexpensive and provide a good surface but they must be sized on both sides first to prevent warping and then properly primed.

Brushes

The best oil-painting brushes are made of bleached hog's-hair bristles. They are strong enough for the thick consistency of oil paint and hold the paint well. There are also soft brushes (sable are the best, but synthetic versions are available and are much less costly) which create smoother, softer strokes and are good for details. They are all available in four basic shapes: filbert, flat, bright and round, the latter being the most versatile. It is always a good idea to buy a variety of sizes, whichever type you choose.

Other equipment

There is an array of accessories to choose from, but the most useful will be a wooden palette. Dippers (small metal cups to hold oil and turpentine or mineral spirits) can be clipped to your palette, but jars are just as good. A mahlstick (a long cane with a pad at one end) is useful for steadying your painting arm when adding fine details. Finally, if your budget will allow you, an easel is an investment that you will not regret.

Techniques

OILS

The following six examples are not actually techniques, but they illustrate the various effects that brushes of differing sizes and substance will make on the support.

1 A 1½ in. (4cm) flat brush. This brush would normally be used for varnishing a finished painting, but it is also extremely useful for filling in extensive areas of colour in the initial stages of a large painting.

2 A ½ in. (1cm) flat, bristle brush. This brush is good for applying short dabs of colour, useful in describing form and texture.

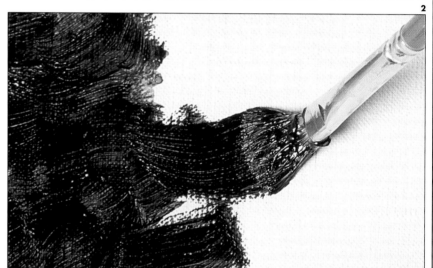

3 A ½ in. (1cm) flat, soft-hair brush. Soft brushes are used for subtle blending and for applying thin glazes of colour. Note how different the marks are to those in the previous example.

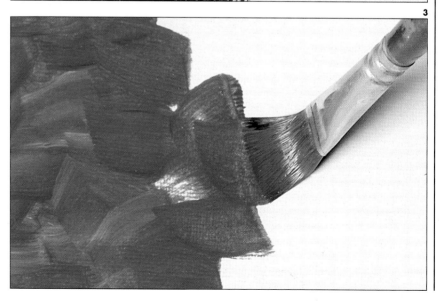

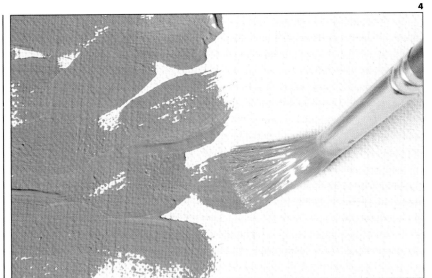

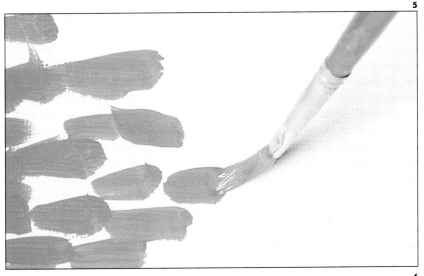

4　A no. 4 round brush. Not essential, but a useful brush for painting very fine strokes and details.

5　A ⅛in. (0.3cm) flat, soft-hair brush. The long bristles of this brush make it sensitive to pressure, allowing you to easily alter the brush mark.

6　A large, round bristle brush. This type of brush holds a lot of paint, so is good for working loosely and for underpainting.

OILS

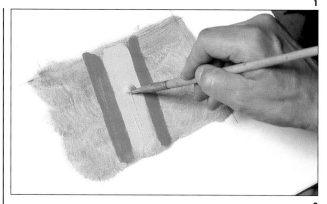

Blending

The following sequence illustrates several blending techniques within the one painting.

Start by laying a base colour and, when it has dried, paint two parallel lines in one colour, and then a lighter tone between them *(1)*. Pull your brush in a zig-zag motion down each side of the centre band to create some spontaneous wet in wet rough-blending of colour *(2)*. The harder you press down on the bristles the more the two colours will merge. This technique is particularly associated with *alla prima* painting, which is where a work is completed in one sitting.

Many artists, however, prefer a softer blending of colours in their paintings. This is done by gently running your brush up and down where the colours meet *(3)*. They are slowly blended together to create a smooth gradation of colour. The light reflection to one side is painted on fairly dry and dragged up and down through the existing paint *(4)* to create an instantaneous blending of colour down its edges, while allowing its true colour to remain where it was painted thickest.

Finally, a band of light paint is applied down the centre, and a dry brush is used to drag it into the background form *(5)*, giving a very smooth transition of tone which completes the cylinder.

Spattering

Spattering is when paint is flicked off a brush to create a shower of tiny droplets.

Lay a base colour in a light tone and, when it has dried, load a stiff brush with a darker tone and run your thumb across the bristles. This will cause the paint to fall as a random spray on to your support. The distance you hold the brush from the support will effect the size of the spray, as will your choice of brush and the consistency of the paint.

Painting Knife

Because the consistency of oil paint is so wonderfully thick, it is possible to create a whole range of textural effects with the use of a painting knife. Using the paint undiluted, scoop some of your chosen colour on to the end of a small painting knife. Using the flat of the knife, cover the area by drawing the paint across the support with irregular strokes. If you choose to use two colours, repeat, using the same technique. The second colour can then be dragged into the first colour to partially mix them.

Mother and Baby

OILS

When people think of oil paintings, they often picture a carefully composed, traditional piece which is time-consuming to produce. But this is only one way of using oil paints. Here we adopt an approach championed by the French Impressionists, which uses bold, expressive brushstrokes and a bright palette, resulting in a lively painting which is very quick to produce.

The reference is a photograph the artist took while on holiday in the south of France. The glorious bright summer sun provides some extremes in contrast, throwing the front of the mother and child into shadow, so heightening their outline. Harsh light presents a challenge to the artist because, if you try to subdue it, the resulting painting can often look unnatural. Instead, as you will discover through this project, if you use the extremes in contrast to good effect – even heightening the shadows and highlights – you will get a very vibrant piece which seems to leap out of the canvas.

1 On a primed 19x22in. (48x55cm) canvas, roughly mark out the main areas of the picture with a 3B pencil. This not only gives a good mark that you can follow as you paint, but also avoids damaging the surface of the canvas.

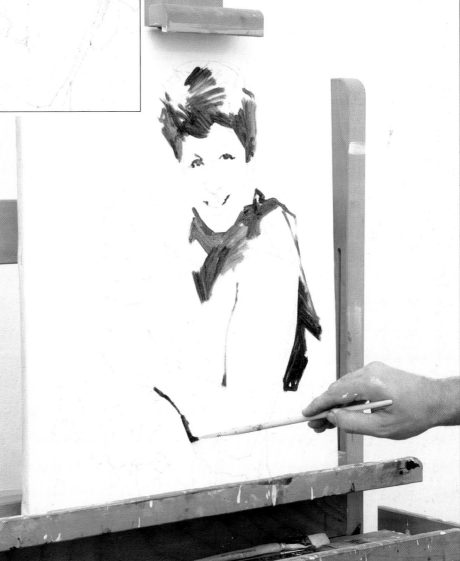

2 Start the painting by mixing together Antwerp blue and burnt umber with a little black to create a very dark tone. Use this to loosely fill in the darkest areas – the mother's hair – with a no.2 filbert bristle brush.

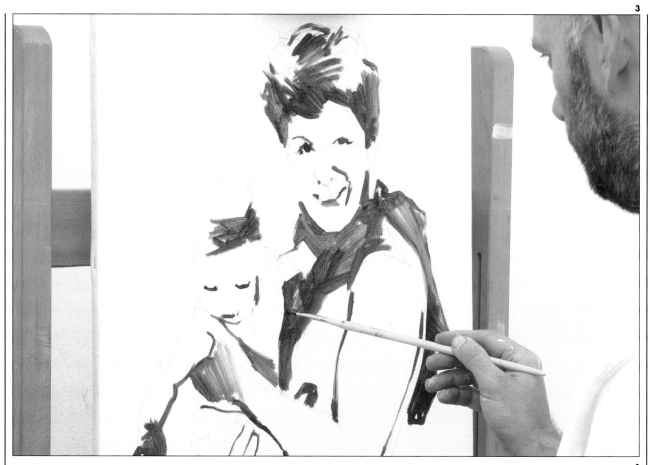

3 Continue by adding cadmium red and yellow ochre into your 'black' mix to create a dark brown with which you can loosely block in the darker skin tones on mother and baby.

Now add titanium white and a little cadmium orange to your mix to create a much richer brown for the slightly lighter skin tones, switching to a no.16 flat bristle brush for the larger areas such as the arm.

4 By adding more cadmium red and titanium white into the mix you will make it go a bit more pink for the shadowy skin tones of the baby. For the lighter skin tones in the shadows simply add a little more titanium white to the mix. Then, by adjusting the ratio of the colours in the mix, you can establish the rest of the mid-range flesh tones on both mother and baby.

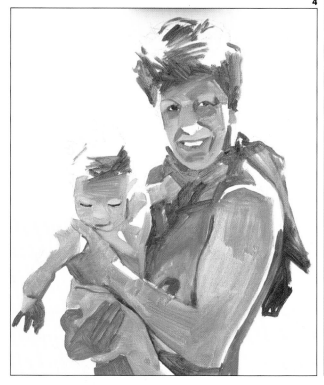

5 Mix a little of the pink you used on the baby's body into yellow ochre and titanium white to create a dark 'straw' tone for the baby's hair. Paint this on with the no.2 filbert brush. Do not worry if it picks up some colour from the adjoining very dark skin tone you painted earlier as it will only enhance the effect.

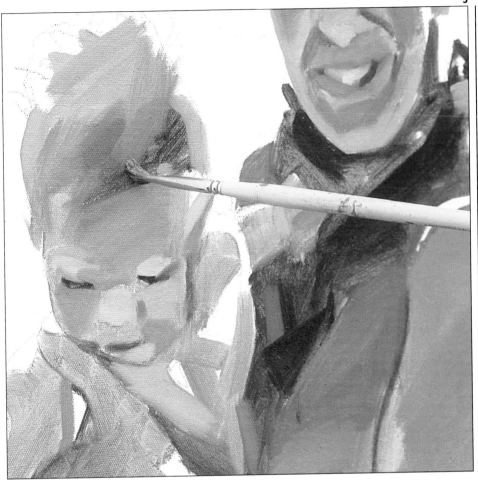

5

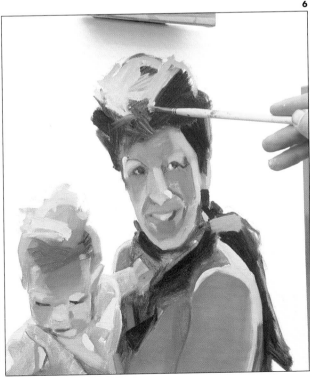

6

6 To the mid-pink tone made in step 4, blend in quite a bit of titanium white and a little cadmium yellow to create a pale skin tone for the next lightest areas on both mother and child. You can even lighten the mix further with more titanium white to provisionally block in the very lightest areas of skin. You will paint over these areas later and make them even lighter, but it is helpful to establish a base tone first on which to work.

Return to the no.16 flat brush and the rich brown skin tone (Antwerp blue, burnt umber, cadmium red, yellow ochre, cadmium orange, black and titanium white). Only put a little paint on your brush and lightly go over the skin, picking up previously laid still-wet paint as you go to blend the areas of tone and darken them slightly.

By mixing together titanium white, Winsor blue and ivory black, you will get a mid-grey which is perfect for the mother's hair and her shawl. For the lighter area on the top of the mother's head, simply lighten this mix with some more titanium white.

7 Mix Winsor blue and titanium white with a little yellow ochre (to make it slightly green) to create a base tone for the sea in the background. Roughly block it in with your no.16 flat bristle brush, varying the mix as you go by adding more blue, white or yellow so that you do not end up with a flat area of one tone.

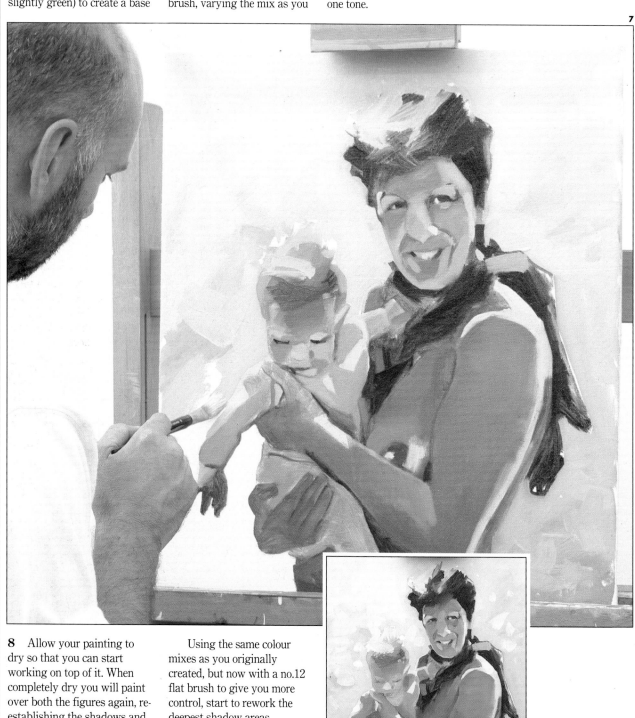

8 Allow your painting to dry so that you can start working on top of it. When completely dry you will paint over both the figures again, re-establishing the shadows and building up the skin tones – in essence, consolidating the painting so that it looks more three-dimensional.

Using the same colour mixes as you originally created, but now with a no.12 flat brush to give you more control, start to rework the deepest shadow areas.

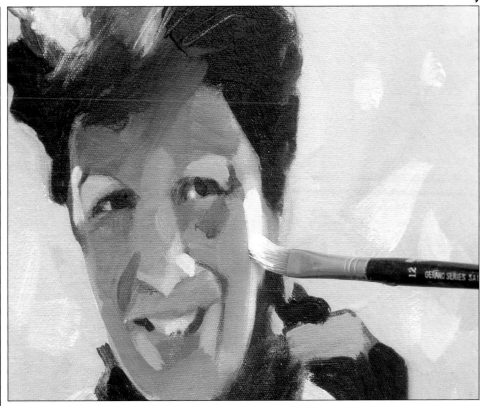

9 Darken the mother's hair and give form to the scarf with ivory black, switching to the no.2 filbert brush for working on any fiddly areas. For the highlights on both figures, dab on some titanium white with a touch of yellow ochre added. White on its own could easily be too harsh and glare out of the painting. By adding a touch of yellow ochre, you warm it up and create more colour harmony with the rest of the painting as so many of the mixes contain yellow ochre.

10 Create a pale blue tone by mixing Winsor blue with titanium white and paint over the top of the water in the background, allowing the previous green-blue layer to show through in places. Break into dabs further down the painting to represent the waves closer to the shore.

11

12

11 Add a lot more titanium white into the mix to make it very light and then dab this on with your finger over the top of the sea to give the effect of bright, mottled light on water.

12 As a final touch, loosely scratch over the still-wet paint on the hair of the mother and baby with the wrong end of your brush to add some texture and to give a suggestion of strands of fine hair.

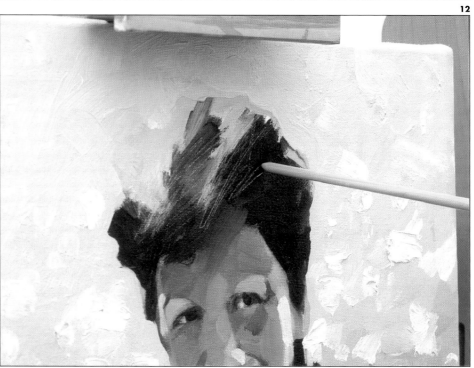

13 Oils are often considered a difficult medium for the beginner to get to grips with. But in reality they give you far greater freedom to correct mistakes (especially essential for the beginner) than other mediums such as pure watercolour. If a watercolour painting goes wrong it is often impossible to correct and so you just have to start again. With oils you can wipe off the paint with a rag dipped in white spirit or simply allow the paint to dry and then paint over the offending area. However, you must take care not to allow yourself to get too carried away, especially with a painting such as this. It is meant to be loose and impressionistic and if you overwork the piece it will become stale and boring.

13

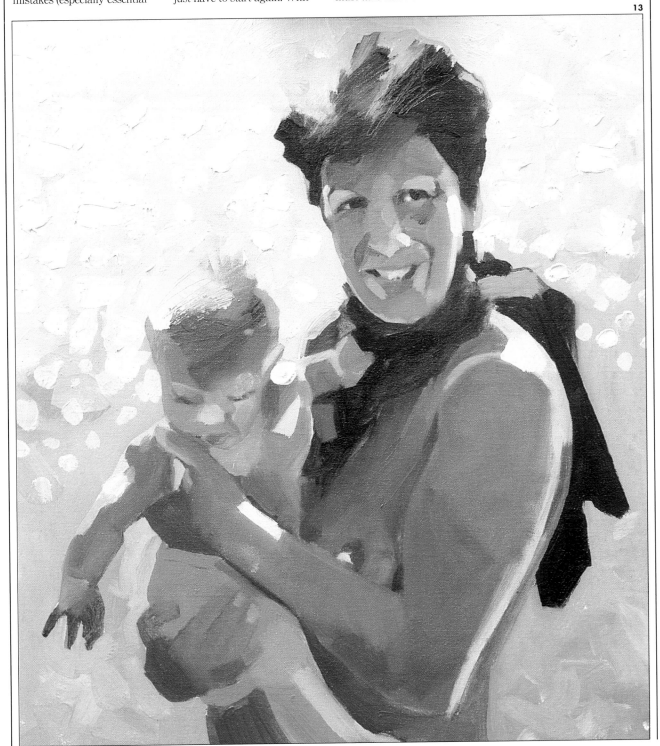

Spanish Senorita

OILS

This Spanish lady was chosen as she looked so proud and it therefore seemed a fitting subject for a formal portrait in oils. The painting itself was conceived in a traditional way by gradually building up the surface with layers of paint over the top of an initial underpainting.

One of the problems of working in this way is the length of time that you have to wait for each layer of paint to dry. However, the process can be speeded up by adding cobalt drier to your paint mix, as we have here. The mahlstick used in this project is also interesting as the artist made it himself by padding the tip of an old junior billiard cue with some scraps of cloth and then covering that in a scrap of chamois leather, tied tightly with thread.

1 Although you can buy your canvas ready primed and cut to size, it is cheaper to buy it unprimed in a larger piece. This way you can cut it to the size you need (in this case 12x15in./31x38cm) and prime it yourself – as we have here – with acrylic gesso. Now, using a 3B pencil, draw out the initial sketch, adding as much detail as you like such as the loosely hatched darkest areas. A soft pencil can be used here as it will not show through the oil paint. Once you are happy, spray the drawing with fixative. This will stop it muddying the paint.

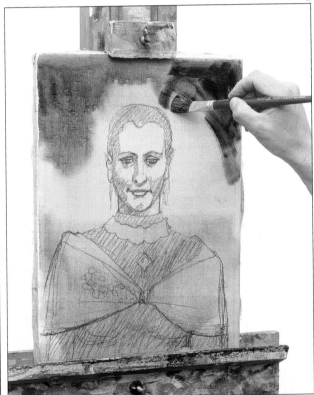

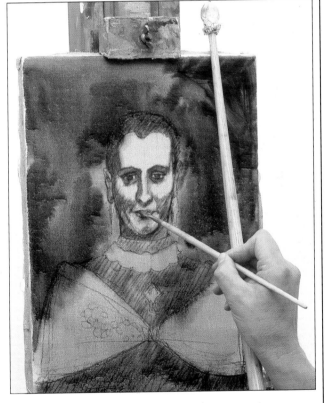

2 With a no.16 flat bristle brush and a mix of turpentine, cobalt drier and burnt sienna lay an overall wash. This will give you an even middle tone, which creates a good base to work in all the lights and darks. While this is still wet, add some Prussian blue to the mix and paint in all general areas of the darkest tone to establish them early on. Do not worry about the dark areas on the shawl for the time being. As they are more detailed, these will be worked on later. At this stage you are really only 'mapping out' the painting.

3 Change to a no.5 flat bristle brush and add some burnt sienna to the medium (turps and cobalt drier) and paint in the darkest areas of the face. This is where a detailed initial pencil sketch proves invaluable as these areas are already mapped out.

Using a mahlstick to steady your hand and a thin mix with some more medium added, paint over the lightest areas to give them more depth. This will provide you with a good solid basis when you start the more difficult, detailed modelling of the facial features.

133

4 Once the first wash has dried, go over the darkest areas of the dress again with a thicker mix (more paint to medium) of burnt sienna and Prussian blue and the same no.5 brush. Next, go over the hair and add the first details of the face such as the eyebrows and pupils of the eyes. Using the same mix but thinned down with more medium, go over the lace ruff at the neck.

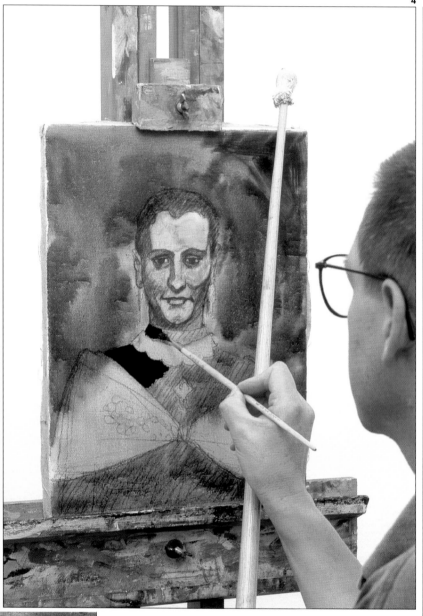

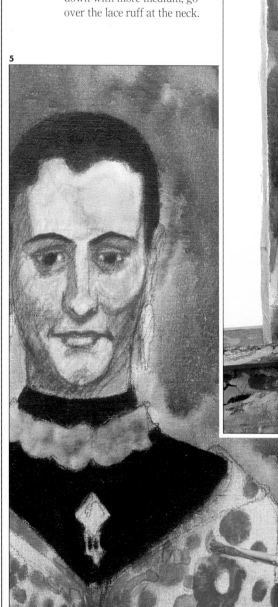

5 While you are waiting for the paint to dry you can begin work on the shawl. With the same no.5 brush and a new, fairly weak (plenty of medium) mix of burnt sienna and cadmium red start to establish the flowers on the shawl. Change to a slightly thicker mix of yellow ochre, Prussian blue and a touch of white to paint in the leaves.

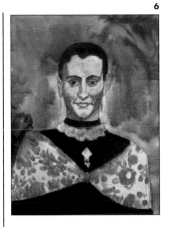

6 Note how the cheeks and the chin, which in the original wash had run and looked slightly messy, have now been tidied up. This was done with a no.5 brush and a mix of burnt sienna and medium. Before proceeding any further you must wait for all the paint to dry to avoid any chance of smudges.

7 Now, turn to the face. With the same brush and a fresh, fairly thick mix (very little medium) of cadmium red, yellow ochre, burnt sienna and titanium white, paint over the dark areas of the face once again. Next, with a mix of cadmium red, yellow ochre and a little white, go over the lighter – but not the lightest –

areas of the face. Switch to a dry brush and work the paint gently to soften the edges. Change to a new mix of yellow ochre, a touch of cadmium red and lots of titanium white with very little medium and paint in the lightest skin tones. Switch to a dry brush again and blend the paint as before.

8 This is a good time to assess the progress of the painting as most of the ground-work has been done. By taking time to do this, it was noticed that the face, the most important part of the painting, was lost against the background. It was decided that, to isolate the face against the background, the latter needed darkening. So, mix some Prussian blue, burnt sienna and titanium white with very little medium – just enough to make it flow – and cover the background using a no.8 flat bristle brush. This mix was chosen to keep it dark, but at the same time differentiate it from the black of the dress. With some Prussian blue and white, paint in the centres of the flowers.

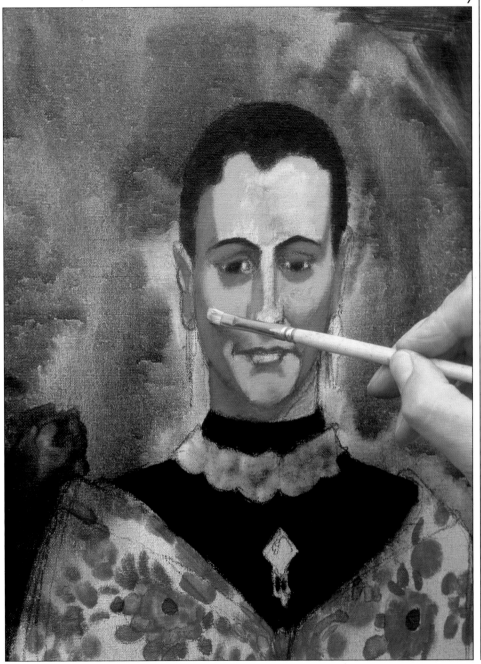

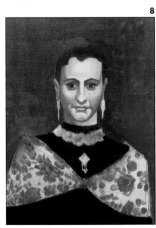

13 With some cadmium red and titanium white, change to a no.4 flat brush and go over the flowers of the shawl with a dabbing motion, twisting the brush slightly as you bring it up to make this mark. Add more titanium white to the mix and go over some of the petals again just to vary the tone. With Prussian blue, yellow ochre and a little titanium white repeat the process for the green leaves, and for the blue leaves with a mix of Prussian blue and white.

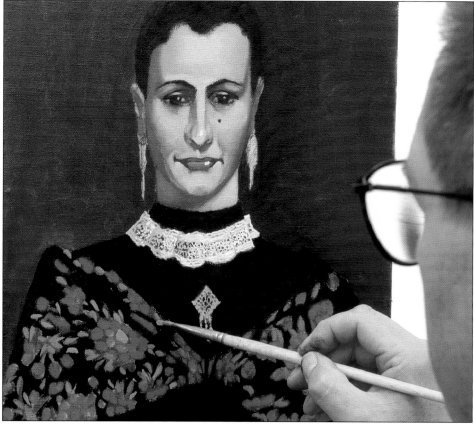

13

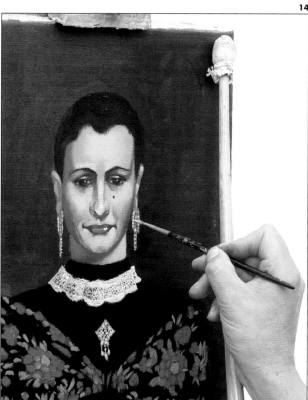

14

14 From now on you are going to be adding the final details, so do not mix too much paint for each element. First switch to a no.3 round soft-hair brush and with cadmium yellow medium and lots of titanium white, paint in the highlights of the brooch. Next mix some burnt sienna, cadmium red, yellow ochre and titanium white and paint over the ears. For the earrings use a fresh mix of burnt sienna, yellow ochre and a little titanium white. Then, when they are almost dry, work over them, adding the highlights with titanium white and yellow ochre. Finally, with some cadmium yellow medium, lots of titanium white and a few spots of cadmium red, dot over the highlights to add extra interest.

15 Although the previous step appeared to finish off all the small details, on stepping back there are still some finishing touches needing attention. The edge between the dark eyelashes and the flesh underneath needs softening, as the contrast between straight black to a light tone is too severe. This is done with cadmium red, yellow ochre, a touch of Prussian blue and the no.3 round sable brush. For the same reason, a mix of burnt sienna and Prussian blue is used to soften all around the top of the head.

The time has really come to call it a day, any further 'tinkering' and the whole piece will look over-worked and rigid. An important lesson to learn when painting, as with most things in life, is to know when to stop.

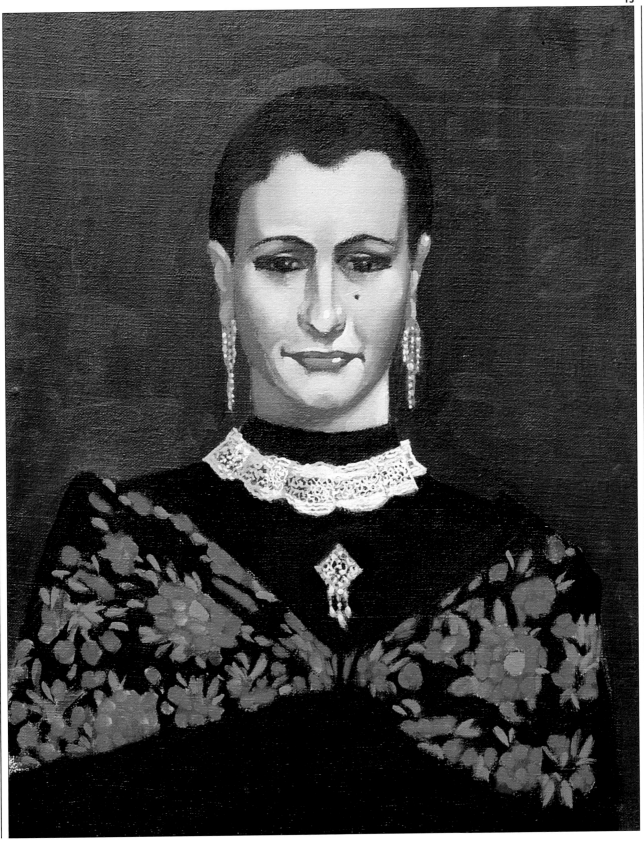

Index

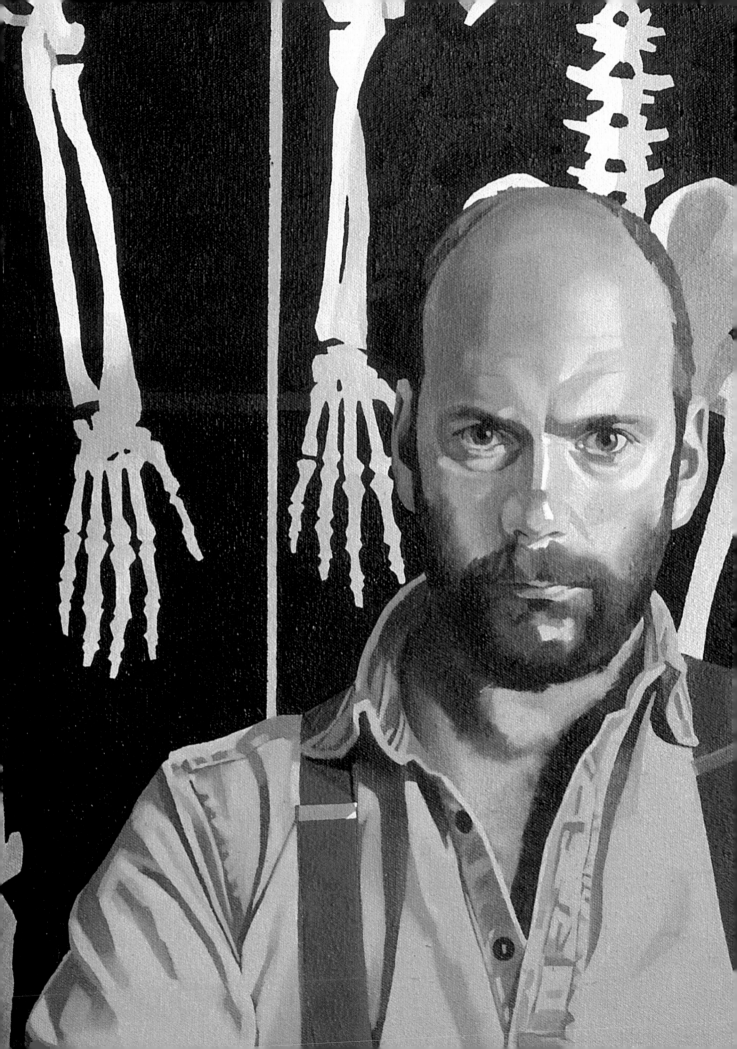